The Isle of Man
Steam Packet
THROUGH TIME

Ian Collard

First published 2013

Amberley Publishing
The Hill, Stroud,
Gloucestershire, GL5 4EP

www.amberley-books.com

Copyright © Ian Collard, 2013

The right of Ian Collard to be identified as the
Author of this work has been asserted in accordance
with the Copyrights, Designs and Patents Act 1988.

ISBN 978 1 4456 1428 1
E-BOOK ISBN 978 1 4456 1432 8

British Library Cataloguing in Publication Data.
A catalogue record for this book is available from
the British Library.

Typeset in 10pt on 13pt Celeste.
Typesetting by Amberley Publishing.
Printed in the UK.

Introduction

Prior to 1767 there were sailings to the Isle of Man from Liverpool or Whitehaven but these were on an irregular basis. This was remedied by the establishment of a regular packet service between Whitehaven and Douglas which sailed from Whitehaven on Monday and returned the following Thursday.

The wooden paddle boat *Elizabeth*, built in 1812 and normally employed on the Clyde, was the first steamship seen in Manx waters. In June 1815 she was damaged in a gale and anchored in Ramsey Bay as seas had ripped off one of her paddle wheels. She anchored in the bay for three days and then sailed for Liverpool, where she was the first steamship to enter the River Mersey. The steamship *Greenock* arrived at Douglas the following year and took passengers on a trip to Laxey.

By 1820 a Scottish company was operating a thrice weekly service from Greenock to Liverpool via Douglas. The *St George* was sailing on a service to the Isle of Man from Liverpool in 1822 and *Victory* was operated by a Manxman, Mark Cosnahan of the Santon Broadstone family, in 1826. He tried to interest Manx businessmen in buying her without success and she sailed on her last voyage in 1829, when she carried Sir John Ross to the Arctic. The Red Pier which replaced the old jetty that had been damaged by the storm of 1787 offered harbourage but passengers were embarked and disembarked by barges.

The steamer from Whitehaven accomplished fifty-two voyages each way in 1813 and the *Duchess of Athol* sailed with passengers from Douglas on 18 October that year and after spending three days and three nights at sea in rough weather was forced back to the island and landed her passengers at Derbyhaven. The *Duke of Athol*, *Douglas*, the *Earl of Surrey* and the *Union* were all employed at various times on the service to the Isle of Man. It was reported that the *Douglas* accomplished a passage from Liverpool in nine hours on one occasion.

In the summer of 1819 the steamer *Robert Bruce* called regularly at the Isle of Man. She operated between Liverpool, Douglas, Portpatrick and Greenock and took passengers to Liverpool on Wednesdays and to Portpatrick on a Friday. She took ten hours on the crossing from Liverpool to Douglas and the following year the company's *Superb*, *Majestic* and *City of Glasgow* also called at Douglas occasionally.

On 16 January 1819 the *Lord Hill* was lost with her crew and passengers at the mouth of the Ribble. In December 1821 it was reported that only one packet vessel managed to sail to

the Isle of Man because of the high winds and rough seas. A vessel also operated between Douglas and Dublin, and another from Peel to Ardglass at this time.

The advantage of a regular packet service to the island was recognised by the local press which commented at the time that the influx of 'visitors [has] almost more than equalled the returns of an ordinary fishery.' The St George Steam Packet Company of Liverpool placed their steamer *St. George* on the Manx service in May, 1822 and she was later replaced by the *Sophia Jane*.

By 1825 the steamer *Triton* was operating a service from Whitehaven to Douglas throughout the year and by 1828 the mail service was transferred to Liverpool when the St George Steam Packet were given the contract to carry it twice weekly in the summer months and once weekly in the winter. However, the steamers were often described as 'shameful hulks, devoid of shelter or accommodation other than that of a small cabin aft and what screen there might be on the lee side of a singularly tall funnel'.

On 17 December 1829, a number of Manx businessmen met under the chairmanship of the High Bailiff, James Quirk at the Dixon & Steele sale rooms. A sum of £4,500 was subscribed for a Manx ship which would be manned by Manxmen and named *Mona's Isle*. The Mona's Isle Company was formed, becoming the Isle of Man Steam Packet Company in 1832.

A contract for the first steamer was placed with John Wood of Glasgow and *Mona's Isle* was launched on 30 June 1830. She arrived at Douglas on 14 August and sailed to Menai Bridge in Anglesey the following day. She was described as 'a small, fast ship whose tall, red, black topped funnel, square ports, square stern and forward paddle boxes, bearing the golden Three Legs of Man'.

She was commanded by Captain Gill, who discovered the Queens Channel in the Mersey Estuary, and left Douglas on her maiden voyage on 16 August 1830. She was immediately in a race with the *Sophia Jane*, which beat her by a minute. However, on each subsequent occasion the *Mona's Isle* was the first to arrive in Liverpool and *Sophia Jane* was later replaced by the larger and faster *St George*. *Mona's Isle* was a fast vessel and completed the voyage between Liverpool and Douglas in around eight hours on average. Robert Napier, who constructed her engines, was very proud of her and later stated that his reputation was made because of the quality and reliability of her machinery.

On 29 November 1830, the *Mona's Isle* and *St George* were forced to leave Douglas harbour after discharging their passengers because of an increase in the wind and deteriorating sea conditions. *Mona's Isle* put out to sea and the *St George* anchored in the bay. The wind increased to a gale later that day and after her cable snapped *St George* was driven onto Conister Rock, where she later broke up. The Douglas lifeboat crew managed to save her crew of twenty-two men.

The St George Steam Packet Company withdrew from the Douglas service later that year, and the Isle of Man Steam Packet ordered a smaller vessel in 1832. *Mona* arrived in Douglas in July that year and prior to operating on the Liverpool service she operated a number of trips to Whitehaven and around the island. She was faster than *Mona's Isle* and completed the voyage to Liverpool in around seven and a half hours and Douglas to Whitehaven in four hours and thirty-five minutes. The mail contract was awarded to the Steam Packet Company on 11 July 1831 for £1,000 a year and by 1834 a daily summer service between Douglas and Liverpool operated.

Several Manx business people founded the Steam Navigation Company in 1835 to rival the services provided by the Steam Packet Company but this company only lasted for two years. *Queen of the Isle* was completed and 'a grand little pioneer trio was created'. The *Glasgow Herald* stated that it had, 'by competent judges, been pronounced one of the finest specimens of naval architecture that has ever floated.' *Mona* was sold to the City of Dublin Steam Packet Company in 1841 and *King Orry* was delivered by John Winram of Douglas. Her engines were supplied by Robert Napier and she reduced the crossing between Liverpool to six and a half hours. She was described as an excellent sea boat.

Queen of the Isle was sold in 1844 and in their first ten years in service the vessels of the fleet carried an average of 10,000 passengers. *Queen of the Isles* was converted into a full-rigged sailing ship and her engines were transferred to the *Ben-my-Chree*, which was the first steamer to be built of iron. A year after *Ben-my-Chree* was delivered, *Tynwald* was also brought into service because of an increase of traffic on the route. She was nearly double the size of her predecessors and her figure-head was a full-length representation of a Manx Scandinavian king in armour. *Mona's Isle* had been advertised for sale since 1837 and it was decided to have her fitted with new boilers by Robert Napier for £500.

Mona's Queen was built in 1852 and she was a smaller but faster vessel than *Tynwald*. She was built by Thomson at Govan with a figure-head of Queen Victoria. The passenger traffic continued to rise and a decision was made to order a larger and faster steamer. *Douglas* was delivered in 1858 by Napier as the first steamer with an upright stem, instead of the bowsprit and figure-head of the earlier steamers. She was long and narrow and as the fastest steamer of the fleet, at seventeen knots, was able to complete the crossing from Liverpool to Douglas in less than four and a half hours.

Her cabin was decorated with views of Peel Castle and Cathedral, Bishops Court, of the Cathedral at Iona, Kirk Braddan and of the towns of Douglas, Castletown, Ramsey and Liverpool. However, after four years of service with the company she was sold to Cunard, Wilson & Co. and Fraser, Trenholm & Co., who were the Confederate Agents, for £24,000 for the purpose of running the blockade during the American Civil War. She was painted grey and renamed *Margaret and Jessie*.

Tod & McGregor of Glasgow delivered the second *Mona's Isle* in 1860. She was more than seventy feet longer than *Queen of the Isle* but she had a slightly smaller tonnage. She was converted to oscillating engines in 1883 and was re-boilered and fitted with a new three-cylinder compound engine by Westray, Copeland & Co. at Barrow. Her name was changed to *Ellan Vannin*, which was the Manx translation of Mona's Isle.

As *Ellan Vannin* she also sailed from Ramsey, Liverpool, Scotland and Whitehaven. She left Ramsey for Liverpool at 01.13 on 3 December 1909 with fourteen passengers, mail and cargo. There was only a moderate breeze when she left the island but the barometer was falling. A Force 12 gale quickly developed and *Ellan Vannin* passed the Bar Lightship at 06.45 but foundered between the Bar and the Q1 buoy. All passengers and crew were lost. The Board of Trade Inquiry found that the storm was one of the worst ever experienced and that she was swept by heavy seas and filled, sinking by the stern. It was stated that the waves had reached the height of 24 feet at the time of her sinking.

Between 1863 and 1876 *Snaefell, Tynwald, King Orry, Douglas* and *Ben-my-Chree* were brought into service. They were faster and larger than their predecessors and were fitted out to a higher quality than the earlier vessels. *Snaefell* took four hours and twenty-one

minutes on her fastest crossing to Liverpool. *Snaefell* and *Douglas* (2) were built with one funnel forward and one aft of the paddle boxes and *Tynwald* had both funnels abaft of the paddle boxes and the main mast close to the after funnel. *Snaefell* was sold to the Zeeland Shipping Company for £15,500 in 1875 for their service between Flushing and Sheerness and renamed *Stad Breda*.

King Orry was delivered in 1871 and was built by R. Duncan & Co. of Port Glasgow. Westray Copeland & Co. of Barrow completed a major overhaul to her in 1888, when she received new boilers, compound engines and a lengthening of the hull. Her speed was increased to 17 knots and this allowed her to continue in service with the Steam Packet until 1912. Prior to her being broken up at Llanerchymor she was thrown open to the public and the proceeds were given to the Holywell Cottage Hospital.

On 1 July 1871, the first passengers arrived at the new Victoria Pier and it was completed two years later. *Ben-my-Chree* (2) was built at Barrow in 1875 as a replacement for *Snaefell*. She was only 14 knots and was re-boilered and lengthened in 1884. She was also fitted with four funnels, in pairs. She survived until 1906 when she was broken up by Thos. W. Ward & Co. at Morecambe. The smaller *Snaefell* (2) was delivered by Caird & Co. of Greenock in 1876. She was chartered for a time by the Dutch company who had purchased *Snaefell* (1). *Snaefell* (2) was re-boilered in 1884 and was sold in 1904 and broken up in Holland.

The single-screw vessel *Mona* joined the fleet in 1878 and was the first vessel fitted with a compound engine, which was more economical to run. She was built by William Laird & Co. at Birkenhead and survived until she was sunk by the Spanish vessel *Rita* on 5 August 1883 while at anchor in the Formby Channel. The daily passenger and mail service was introduced in 1879 and operated throughout the year, Sundays excepted. The twin-screw vessels *Fenella* (1) and *Peveril* (1) were handed over to the company in 1881 and 1884 respectively.

An inquiry in 1910 established that three passengers had lost their lives when they had refused to go below on *Fenella* (1) and had been washed overboard. This was the only time, apart from the *Ellan Vannin* sinking, that lives had been lost on a Steam Packet vessel. During the First World War *Fenella* (1) maintained the Liverpool–Douglas route when the other ships of the fleet were chartered to the Admiralty. She gave sterling service to the company and was sold in 1929 for £2,290 and was broken up by John Cashmore at Newport. *Peveril* was sunk on 16 September 1899, following a collision with the *Monarch* off Douglas. The crew and passengers were taken on board the *Monarch* and landed at Douglas.

The Steam Packet returned to paddle steamers and *Mona's Isle* (3) was launched at the yard of Caird & Co. at Greenock on 16 May 1882. She was followed by *Mona's Queen* (2) in 1885, which was built by the Barrow Shipbuilding Co. Ltd at Barrow. These two vessels had service speeds of 18/19 knots and *Mona's Isle* (3) completed a voyage from Liverpool to Douglas in three hours and thirty-five minutes. In May 1885, *Mona's Isle* (3) damaged one of her paddle-wheels in rough weather and these were later strengthened and new floats were fitted in 1886. On 6 September 1892 she stranded on Scarlett Point, near Castletown, and was re-floated two days later. During the First World War she was converted to an anti-submarine net layer by the Admiralty and did not return to the Steam Packet at the end of hostilities.

Mona's Queen (2) was employed on the Fleetwood route and was returned to her builders at the end of her first season to have her boilers adjusted. She was a very successful vessel and regularly completed the route between Douglas and the Wyre Light in less than three

hours. She was taken over by the Admiralty at the start of the First World War and in February 1917 she observed a German U-boat on the surface. Captain Cain decided to attempt to ram the submarine and after a torpedo was fired at the ship he managed to break open the U-boat's hull. The submarine later sank. She returned to the Isle of Man service at the end of the war and became the last paddle steamer in the fleet before she was broken up at Port Glasgow in 1929.

The Isle of Man, Liverpool & Manchester Steamship Co. (Manx Line) started a service to the Isle of Man in competition with the Steam Packet in 1887. The *Queen Victoria* and *Prince of Wales* were built by the Fairfield Shipbuilding Co. on the Clyde. *Queen Victoria* took only nine hours and twenty minutes to reach the Mersey on her delivery voyage from Glasgow, averaging a speed of 22½ knots.

A price war soon developed, with the Steam Packet reducing fares and the Manx Line advertised a 3½ hour passage. Fares were reduced to 5s first class and 2s 6d second class. On 19 May 1888, *Mona's Isle* (3) and *Queen Victoria* participated in a race, with the latter winning by 32 minutes. The *Prince of Wales* is recorded as making the voyage from the Rock Buoy in the Mersey to Douglas Head in two hours 59 minutes. A double daily service was introduced by the Steam Packet and both companies recorded a loss during this period. At the end of the 1888 season both Manx Line vessels were purchased by the Steam Packet. The Isle of Man Steam Navigation Co. (Lancashire Line) ran a service to the Isle of Man in 1887 with the *Lancashire Witch*. The service proved unsuccessful and the vessel was sold in May the following year.

Tynwald (3) was built by the Fairfield Shipbuilding Co. and arrived in Douglas from the Clyde on 27 June 1891. She was certified to carry nearly twice as many passengers as the *Fenella* (1) with a service speed similar to *Mona's Isle* (3). *Tynwald* was employed on the Liverpool–Douglas winter service and in July 1912 she operated on a new Douglas and Ramsey to Whitehaven route as well as working on the newly opened Ardrossan–Douglas service. During the First World War she operated on the Liverpool–Douglas route with *Fenella* (1) and in 1914 she carried the first German prisoners of war to the island for internment at Knockaloe. She conveyed British troops to Dublin in 1916 to deal with the Easter rebellion and rescued sixty passengers from the *New York*, which had been mined near the Mersey Bar. She was employed in excursion trips from Blackpool to Morecambe, Douglas and Llandudno and then laid up at Barrow from 1930 to 1933.

She was purchased by Mr. R. Colby Cubbin of Douglas in 1934, converted to a private yacht and renamed *Western Isles*. She was requisitioned by the Admiralty in 1940 and used as an anti-submarine training ship, becoming *Eastern Isles* on 27 October 1941, and also as an accommodation ship for HMS *Eaglet II* at Liverpool. In April 1946, she was transferred by the Royal Navy to the Director of Sea Transport and returned to her owner the following year. She left Birkenhead on 13 May 1951 for Spezia to be broken up.

Empress Queen was said to be the 'largest and swiftest paddle steamer in existence'. She was built by the Fairfield Shipbuilding Co. in 1897 and named to commemorate the Diamond Jubilee of Queen Victoria. *Empress Queen* was converted to a troopship at Barrow in 1915 and grounded in thick fog off the Isle of Wight on 1 February 1916, where she was declared a total loss and was gradually destroyed by the wind and sea.

In 1897, the steamer *Munster* was purchased by Higginbottom and others to provide a service to the Isle of Man. The two other vessels, *Leinster* and *Ulster*, were purchased by the

Steam Packet that year to prevent the opposition company providing a service. Two years later Higginbottom formed the Liverpool & Douglas Steamers Limited and purchased the *Ireland*, which had previously operated between Holyhead and Kingstown. The company also purchased two small, slow paddle steamers called *Normandy* and *Brittany* which had operated on the Newhaven–Dieppe route, and the *Lily*, *Violet* and *Calais/Douvres*.

The competition on the Liverpool–Douglas route led to the Steam Packet being forced to reduce their fares. The ships of the competing companies were involved in races and crowds of people would often be seen at Liverpool Pier Head and Douglas as the ships arrived or departed each port. As the Liverpool & Douglas Steamers Limited was operating at a heavy loss, it finished trading on the death of Mr Higginbottom in December 1902. *Calais/Douvres* was purchased by the Steam Packet and renamed *Mona* (3).

In 1901, *Dora* was purchased from the London & South Western Railway. She was built in 1889 by Napier's and had been operated on the Southampton–Channel Islands service. The Steam Packet renamed her *Douglas* (3) for the Isle of Man services. On 6 November 1903 she collided with and sank the *City of Lisbon* in the River Mersey. *Douglas* (3) was used by the company on the winter services and was not taken over by the Admiralty during the First World War. On 16 August 1923 she collided with the *Artemisia* while leaving Coburg Dock. The captain of the *Artemisia* used his engines to hold the bow of his vessel in the hole in *Douglas*'s side, keeping her afloat while the crew and passengers were rescued by other craft in the river.

Viking was launched on 7 March 1905 by Armstrong, Whitworth & Co. at Newcastle. She was designed as a triple-screw vessel and powered by three Parsons Marine steam turbines. She was ordered for the Fleetwood service to run in opposition to the Midland Railway Company's *Manxman*, which operated on the Heysham–Douglas service. On 25 May 1907, she completed the run in two hours 22 minutes. *Viking* was built with accommodation for 2,000 passengers.

She was taken over by the Admiralty in 1915, renamed *Vindex* and converted to a seaplane carrier to operate off the Dutch and Belgium coasts and also in the Mediterranean. From her decks on 3 November 1915, Flight Lieutenant Fowler made the first successful flight in an aircraft with a wheeled under-carriage, a Bristol Scout. In March 1916 she mounted an attack on the Zeppelin sheds at Tondern, and in the same year one of her Bristol Scouts attacked a Zeppelin over the North Sea unsuccessfully. As one of the vessels selected for experiments with dazzle-painting in 1917, she received a camouflage pattern devised by the artist Norman Wilkinson. In 1919, she was re-purchased by the Steam Packet and converted back to a passenger vessel, returning to the Fleetwood service in 1920. *Viking* operated with the *Lady of Mann* on this service from her arrival in 1930 and was also seen on the Steam Packet's other routes.

At the outbreak of the Second World War, she was again requisitioned by the Admiralty as a troopship and carried men to France. In June 1940 she carried 1,800 children from Guernsey to England when German forces invaded France. However, the following year she was laid up at Douglas and later in the war she completed trooping duties to Orkney and Shetland. She was operating off the French coast on D-Day and on 28 June 1944 she was seriously damaged by a bomb at Rotherhithe. *Viking* returned to the Steam Packet in 1945, and was again placed on the Fleetwood–Douglas service. In 1949, she undertook a major overhaul and her turbines were re-bladed by Cammell Laird in the winter of 1950/51. Her

final voyage on the Fleetwood service was made on 14 August 1954 and she was broken up at Barrow. Her bell was presented to the town of Fleetwood.

Ben-my-Chree (3) was launched on 24 March 1908 by Vickers, Sons & Maxim at Barrow. She was fitted with triple screws and three turbines, which gave her a speed of 26.9 knots on trials. She was designed to carry 2,700 passengers, with 116 crew. On 6 July 1909, she made the passage between Liverpool Landing Stage and Douglas in 2 hours 57 minutes.

Ben-my-Chree (3), *Viking* (1) and the *Manxman* from the Midland Railway Company were taken over by the Admiralty in 1915 and converted in a similar way, with permanent hangers built aft. The *Vindex* and *Manxman* had removable take-off platforms forward. The *Ben-my-Chree* (3) was the fastest of the trio and spent her entire operational career in the eastern Mediterranean. However, she was given the duty of delivering explosives for the sinking of the German cruiser *Konigsberg*, which was sheltering in the River Refugi. She was the first vessel to mount successful airborne torpedo attacks with her seaplanes. Three of the aircraft scored hits on Turkish merchant vessels in June and August 1915, and also sank a tug.

In 1917 the *Ben-my-Chree* (3) was hit during a bombardment by a Turkish shore-battery while she lay anchored off Castellorizo in the Aegean. The petrol for her aircraft caught fire and she sank. Her wreck was raised in 1920 and demolished at Piraeus.

Snaefell (3) was delivered by Cammell Laird in 1910 and was taken over by the Admiralty at the outbreak of the First World War. She worked with the Plymouth Patrol and escorted the monitor *Raglan* to the Dardanelles in 1915. She was also used as a seaplane carrier and in 1917 was converted at Genoa as a troopship. In April the following year she was being refitted at Alexandria and was seriously damaged by fire. Temporary repairs were carried out and she was able to sail for Malta. However, on 5 June 1918 she was torpedoed and sunk by a German submarine.

The cargo vessel *Tyrconnel* was purchased by the company in 1911. She was built in 1892 at Paisley and had a service speed of 9 knots. She remained with the Steam Packet until 1932, when she was sold to W. J. Ireland of Liverpool and was broken up at Danzig two years later.

The *Duke of York* and *Duke of Lancaster* were owned jointly by the Lancashire & Yorkshire Railway and the London & North Western Railway and operated on the Fleetwood–Belfast joint service. They were sold in 1911 to Turkish interests, and later to the Steam Packet. They were renamed *Peel Castle* and *The Ramsey*, later shortened to *Ramsey*. At the beginning of the First World War *Ramsey* operated as an armed boarding vessel based at Scapa Flow. In August 1915 she was in the North Sea, and after challenging a steamer which was flying a Russian flag, the German flag was hoisted and *Ramsey* was fired upon, and was struck with a torpedo. She sank with a loss of fifty-two lives.

Peel Castle was also requisitioned by the Admiralty, becoming an armed boarding vessel and later carrying out trooping duties. She was returned to the Steam Packet in July 1919. On 7 June 1924, she went ashore in Douglas Bay in fog and for a period took the regular Friday Liverpool–Ramsey sailing. She acted as a tender at Douglas to the White Star liner *Albertic* in 1927, and in 1933 took a sailing to Warrenpoint. *Peel Castle* survived until 1939, when she was sold and broken up by Arnott Young at Dalmuir.

King Orry (3) was the first Steam Packet vessel with geared turbines driving her twin screws. She was built by Cammell Laird at Birkenhead in 1913 and acted as an armed boarding vessel at the beginning of the First World War. Following the Battle of Jutland she

became a target-towing ship and was armed with two 4-inch guns, two 3-pounders, one 12-pounder and a 3-pounder anti-aircraft gun. At the end of 1916 she became the Norwegian vessel *Viking Orry* in disguise. In November 1918 she was present at the surrender of the German High Seas Fleet at Scapa Flow when, accompanied by HMS *Phaeton* and HMS *Castor*, she followed Rear Admiral Sir Alexander Sinclair in the light cruiser HMS *Cardiff*, which led twenty-one German ships. She was returned to the Steam Packet the following year and went aground off the Rock Lighthouse at New Brighton on 19 August 1921. She was later re-floated. *King Orry* (3) received a major overhaul in 1935 and was converted to burn oil in 1939. Requisitioned again by the Admiralty in 1939, she became an armed boarding vessel in the English Channel and later from the Humber. While assisting the evacuation of the troops at Dunkirk she was bombed and sunk.

Mona (4) was built for the Ardrossan–Portrush service for the Laird Line as *Hazel* by the Fairfield Shipbuilding Co. in 1907. She was the first of five vessel purchased by the Steam Packet in 1919 and 1920 to replace vessels lost in the First World War. At the outbreak of the war the company owned fifteen steamers and eleven of these were chartered or purchased by the Admiralty. Four of these were lost and three were never returned by the government. The Liverpool & North Wales passenger steamer *La Marguerite* was chartered by the Steam Packet in 1919 to provide services to the Isle of Man. *Mona* was placed on secondary and night services and in 1930 she ran aground on the Conister Rock in Douglas Bay. After the 1936 season she was used only in the summer or to carry cargo not passengers. She was sold to be broken up by E. G. Rees of Llanelli in December, 1938.

Manxman was purchased from the Midland Railway in January 1915 by the Admiralty, who sold her to the Steam Packet in 1920. During the First World War she operated as a seaplane carrier in the Mediterranean. She had operated on the railway company's Heysham route and retained her original name. *Manxman* was converted to burn oil in 1921 and together with *Manx Maid* she maintained the company's services to the island in 1926, during the General Strike. At the outbreak of the Second World War she was again requisitioned by the Admiralty for use as a troopship, then a naval tender and, as HMS *Caduceus*, as a Radar vessel, initially operating from Douglas. However, she suffered several accidents and was damaged twice entering Douglas harbour and was transferred to the Clyde. She later gave service as a troopship and sailed between the Hook of Holland and Harwich and the Port of Dover. She was laid up at Barrow in 1949 and broken up at Preston later that year.

Onward was purchased from the South Eastern & Chatham Railway in May 1920 and renamed *Mona's Isle* (4). She was built and engined by William Denny & Bros at Dumbarton in 1905 and based at Dover and Folkestone. She had been employed as a troopship during the First World War and had been bought by the Admiralty. Following purchase by the Steam Packet she sailed from London on 15 May 1920 for Liverpool but was not renamed until 27 August that year. On 29 June 1936, she struck the Devil's Rock in Balscadden Bay but reached Dublin safely, where temporary repairs were carried out. She became an armed boarding vessel in the North Sea at the beginning of the Second World War and was damaged at Dunkirk. Returned to the Steam Packet services in 1945, she survived until 1948 when she was broken up at Milford Haven.

Viper was built by the Fairfield Shipbuilding Co. for G. & J. Burns's service between Ardrossan and Belfast. She was purchased by the Steam Packet in 1920 and renamed *Snaefell* (4). She had served as a troopship in the English Channel during the First World

War, returning to the Irish Sea in 1919. In 1928 she was operating from Heysham and in 1933 she replaced *Victoria* on this service. At the beginning of the Second World War she was operating as a troopship and was returned to the Steam Packet in 1940 to provide a service with *Rushen Castle* from Fleetwood to the island. She was withdrawn from service in 1945 and sold for demolition. She was towed to Port Glasgow and was laid up there for three years before she was finally broken up.

The three-masted *Ardnagrena* was purchased in 1920 and renamed *Cushag*. She was built in 1908 by G. Brown & Co. at Greenock and was able to use the harbours at Peel, Port St Mary, Castletown and Laxey in addition to Douglas and Ramsey. She was sold on 26 January 1943 to T. Dougal of Stornoway and broken up at Grangemouth in July, 1957.

The London & South Western Railway steamer *Caesarea* was purchased in 1923 and renamed *Manx Maid* (1). She was one of two sisters built for the Channel Islands service from Southampton. She went aground on 7 July 1923, near St Helier, and was sent to Cammell Laird at Birkenhead to be repaired. It was while she was undergoing this work that she was purchased by the Steam Packet and she entered their service in 1924 after being converted for oil burning. She was employed as an auxiliary to the Royal Air Force and later a troop ship during the Second World War. In 1941 she was renamed HMS *Bruce* as a Special Duties vessel operating with the Fleet Air Arm, from late 1942 to March 1946. On return to the Steam Packet she was used mostly at weekends and for relief duties. She was broken up at Barrow in 1950 by T. W. Ward & Co. Ltd.

Ben-my-Chree (4) was launched at the yard of Cammell Laird & Company on 5 April 1927 and sailed on her maiden voyage from Liverpool to Douglas on 29 June that year. She was the Steam Packet's first new steamer since the end of the war and was designed as a twin-screw turbine vessel with an enclosed promenade deck and partially enclosed shade deck. Her hull was painted white with green boot topping in 1932, together with *Mona's Queen* (3) and *Lady of Mann* (1).

In 1939 she was requisitioned by the Admiralty as a troop transport and operated in the English Channel and was involved in the evacuation of troops from Dunkirk. She saw service in the Faroes and sailed to Iceland on one occasion. She was moved from her Scottish base to North Shields in 1944 and operated in the English Channel in preparation for D-Day. She later operated from Dover and Southampton before being returned to the company. Her funnel was shortened in the winter of 1949/50 during an overhaul and the cowl was removed the following year. *Ben-my-Chree* (4) made her final sailing for the company on 13 September 1965, from Douglas to Liverpool, and was laid up in Morpeth Dock, Birkenhead, and placed up for sale. She was renamed *Ben-my-Chree 2*, to allow the name to be given to a new drive on/drive off car ferry being built by Cammell Laird at Birkenhead. She was towed to Bruges by the tug *Fairplay XI* and arrived on 23 December 1965.

The Steam Packet took over the service from Heysham to Douglas in 1928 from the London, Midland & Scottish Railway and bought the steamers *Antrim* and *Duke of Cornwall*. *Antrim* had been built in 1904 by John Brown at Clydebank for the railway's Heysham–Belfast service. She was renamed *Ramsey Town*, later *Ramsey*, and operated on the company's services until 1936, when she was withdrawn and broken up at Preston in April 1937.

Duke of Cornwall was built by Vickers, Sons & Maxim Ltd at Barrow in 1898 for the Fleetwood–Belfast joint service of the LNWR and the L&Y Railway. She was renamed *Rushen Castle* and operated the service from Liverpool and later from Fleetwood during

the Second World War. On 27 January 1940 she sailed for Douglas at 10.45 a.m. and was told to go to Peel as an easterly gale was developing. As the war-time message was not clear, Captain Bridson proceeded to Douglas, where he was told by signal to make for Peel. On reaching Peel the weather had further deteriorated and *Rushen Castle* was not able to berth until 10.00 a.m. on 30 January. She had been at sea for 71 hours. *Rushen Castle* re-opened the Liverpool–Douglas route on 6 April 1946 but was later laid up at Douglas. She was towed to Ghent on 9 January 1947 by the tug *Ganges* and broken up.

The *Victoria* was built in 1907 for the South Eastern & Chatham Railway's Dover–Calais service. She was purchased for £25,000 in 1928, but various alterations to her brought the total cost to £37,550. She was the last triple-screw, direct drive, turbine ship in the Steam Packet fleet. In 1938 she was chartered by the LMS for one day on the August Bank Holiday service from Holyhead to Dun Laoghaire. In 1940, on a voyage from Douglas to Liverpool, near to the Q1 Buoy, two mines exploded behind her but no damage was sustained. She was mined, eight miles north-west of the Bar Lightship, on 27 December that year. She was without power and the passengers were taken aboard the trawler *Michael Griffith*. The naval yacht *Evadne* stood by her until the minesweeping trawlers *Doon* and *Hornbeam* arrived to tow her back to Liverpool. She was returned to the Steam Packet at the end of hostilities and remained with them until 1957, when she was towed from Birkenhead to Barrow on 25 January to be broken up by T. W. Ward & Co. Limited.

The cargo vessel *Peveril* was delivered to the company by Cammell Laird in 1929. She cost £42,600 and was the first purpose-built cargo ship ordered by the Steam Packet. She was built with accommodation for seventeen crew and twelve passengers and spent most of her life on the Liverpool to Douglas or Ramsey routes. She was sold to the Belton Shipping & Trading Co. and left Douglas as *Peveril II* on 28 May 1964 to be broken up at Glasson Dock.

The *Lady of Mann* (1) was delivered to the Isle of Man Steam Packet in their centenary year. She was launched on 4 March 1930 by Her Grace the Duchess of Athol and sailed on her maiden voyage on 28 June that year. She was built by Vickers Armstrong at Barrow, cost £249,073 and was the largest ship ever built for the company. She had a similar war history to the *Ben-my-Chree* (4), spending time trooping to the Faroes. She returned to the fleet on 14 June 1946 following an overhaul by Cammell Laird at Birkenhead and sailed on the company's routes until she was withdrawn from service on 17 August 1971. She was sold and left Barrow on 29 December that year under tow by the tug *Wrester* for breaking up by Arnott Young at Dalmuir, where she arrived on 31 December.

Abington was built in 1921 and was owned by G. T. Gillie & Blair, Newcastle upon Tyne. She was purchased by the Steam Packet in January 1932 for £5,500 and her name was changed to *Conister*. She was the last coal-fired ship owned by the company and the last with reciprocating triple-expansion engines. She was seriously damaged by a bomb in Queens Dock, Liverpool, on 27 October 1940 and was repaired and survived until she was withdrawn from service in 1965, towed to Dalmuir by the tug *Campaigner* and broken up.

Mona's Queen (3) was launched on 12 April 1934 at Cammell Laird's yard at Birkenhead. Together with *Lady of Mann* (1) and *Ben-my-Chree* (4) she was painted white in 1932. However, she differed from them as her promenade deck was extended forward to the bow, giving the impression that she was larger than the *Lady of Mann* (1). *Mona's Queen* (3) inaugurated evening cruises to the Calf of Man from Douglas. She was lost during the evacuation of Dunkirk on 29 May 1940.

Fenella (2) and her sister *Tynwald* (4) were built by Vickers Armstrong at Barrow in 1937. Both vessels were launched on 16 December 1936 and were the first vessels in the Steam Packet fleet to have cruiser sterns and the first two vessels to be exact sisters. Their accommodation was far superior to previous vessels and this was appreciated by passengers when they were placed on the Liverpool–Douglas winter service. *Fenella* (2) sank at Dunkirk on 29 May 1940 and *Tynwald* (4) was sunk by enemy action at Bougie, 150 miles east of Algiers, on 12 November 1942. It was later reported that *Fenella* (2) was raised by the Germans, re-engined and used for further service during the war but no evidence can be found to substantiate this story.

At the end of hostilities it was clear that the Steam Packet would have to embark on a fleet replacement policy after losing four of their vessels during the war. *Peveril* (2), *Conister* (1), *Snaefell* (4) and *Rushen Castle* (1) had maintained the service to the island and these were joined by *Viking* (1), *Mona's Isle* (4), *Victoria* (1), *Manx Maid* (1), *Lady of Mann* (1) and *Ben-my-Chree* (4).

King Orry (4) was launched on 22 November 1945 and sailed on her maiden voyage on 18 January the following year. She was a development of the design of *Fenella* (2) and *Tynwald* (4). On 31 January 1953, during a storm in the Irish Sea, it was reported that the *Princess Victoria* was in trouble on a voyage in the North Channel. *King Orry* sailed from Liverpool under Captain Bridson and because a radio silence was imposed she was unable to report her position and she arrived at Douglas safely after an eleven hour crossing. She had her cowl top removed from her funnel in 1961. Her final passenger voyage was from Llandudno to Liverpool on 31 August 1975 and she was sold to R. Taylor & Sons, Bury, to be broken up. During a storm on the night of 2 January 1976 she broke away from the quay at Glasson Dock and went aground. She was there for three months before being re-floated and towed to Rochester, where she was broken up by Lynch & Son.

King Orry (4) was followed by *Mona's Queen* (4), which was launched at Birkenhead on 5 February 1946. She was almost identical to *King Orry* (4), cost £411,241 and sailed on her maiden voyage on 26 June that year. For sixteen years she operated on the company's routes and in 1962, when the Fleetwood berth was declared unsafe, she was redundant and placed on the for-sale register. She was sold to the Chandris Group and renamed *Barrow Queen* for the voyage to Greece. Following conversion for cruising she became *Carissima*, *Carina* and *Fiesta*.

Tynwald (5) emerged from Cammell Laird's yard the following year. She cost £461,859 and was a near sister of the previous two vessels of the class. She was launched on 24 March 1947 and sailed on her maiden voyage on 31 July that year. On 25 February 1952 she sank the barge *Eleanor* in the Mersey. *Tynwald* was withdrawn from service in 1974 and sold to John Cashmore Ltd at Newport but was later re-sold to Spanish ship breakers and towed to Aviles by the tug *Sea Bristolian* and broken up in 1975.

Cammell Laird's delivered *Snaefell* (5) in 1948 and she sailed on her maiden voyage on 24 July that year. She was another near sister but the cost for her to be built had risen to £504,448. She differed in that she had the windows of the shelter deck carried aft and two more windows below her bridge in her main lounge. She also had the Legs of Man on her bow. *Snaefell* (5) and *Mona's Isle* (5) were the last ships on the Heysham–Douglas service when it closed in August 1974. She was sold to Rochdale Metal Recovery Co. and towed by the tug *George V* to Blyth on 24 August 1978. She arrived on 8 September and was broken up by H. Kitson, Vickers & Co.

The cargo ship *Fenella* (3) was delivered to the Steam Packet by the Ailsa Shipbuilding Co. at Troon in 1951. She was the company's first motor ship and was powered by a 7-cylinder British Polar engine of 1,185 indicated horsepower. As the loading berth at Douglas was tidal, the diesel generators were cooled by circulating water from the ballast tanks at low water when the vessel was high and dry. She was sold to E. Mastichiades of Piraeus and renamed *Vasso M* and left the Mersey on 9 February 1973 under her own steam. She suffered a serious fire in the Mediterranean in May 1978 and sank.

Another product of Cammell Laird's yard at Birkenhead was *Mona's Isle,*which entered service for the Steam Packet on 22 March 1951. She cost £570,000 and was also a near sister of the previous vessels and differed by having her steel hull built up around the stern. On 8 June 1955, she went aground following a collision with the fishing vessel *Ludo*. One life was lost when the *Ludo* was cut in half and sank. On 15 February 1964, she went aground at Peel and had to be towed back to Liverpool for repairs and dry-docking to be completed. *Mona's Isle* re-opened the Fleetwood service in August 1971 and took her last voyage for the company on 27 August 1980. She left Birkenhead under tow of the tug *Afon Wen* on 30 October 1980 and was broken up in Holland.

The last member of the class, *Manxman*, was delivered by Cammell Laird in 1955. She cost £847,000 and differed from the others by having Welin davits for her four aft lifeboats and her Pametrada turbines were driven by superheated steam at 350 pounds p.s.i. Double reduction gearing was used to drive the two propellers at 270 rpm and she developed a nominal shaft horsepower of 8,500. *Manxman* sailed on her maiden voyage on 21 May 1955. She was chartered to a film company in March 1979 and was converted to the liner *Carpathia* for the filming. She sailed on her last passenger voyage on 4 September 1982, on a return sailing from Liverpool to Douglas. The following day she sailed to Preston carrying around 1,000 passengers and berthed in the Albert Edward Dock in preparation for her new static role as an entertainment centre.

Prior to 1962 and the introduction of the company's first purpose-built car ferry, *Manx Maid* (2), vehicles were lifted on and off the steamers at Douglas except at high tide when they were able to be driven off by ramps. The *Manx Maid* (2) was the Steam Packet's first drive on/drive off car and passenger ferry and was designed with a series of ramps to enable vehicles to be driven on and off at all stages of the tide at Douglas. She was also the company's first ship to be fitted with stabilisers, was certified for 1,400 passengers and ninety cars and was fitted with Babcock & Wilcox integral furnace boilers, installed instead of the sectional header type. Her two double-reduction geared turbines developed a brake horsepower of 9,500. In 1979 she was fitted with a bow thruster unit to assist in berthing. She collided with the Fort Anne jetty in Douglas in November, 1974.

The single-screw motor vessel *Peveril* (3) was delivered in 1964 from the Ailsa Shipbuilding Co. at Troon. She was fitted with a 7-cylinder British Polar engine, direct-acting, developing 1,400 brake horsepower. She was originally fitted with two 10-ton cranes and was converted to carry containers by her builder in 1972.

The smaller cargo vessel *Ramsey* (1) was built by the Ailsa Shipbuilding Co. the following year. She cost £158,647 and was powered by a 6-cylinder British Polar engine, which developed 490 brake horsepower. She was designed to be able to use the smaller ports around the island and following the introduction of containerisation and conversion of *Peveril* (3), it was established that a second larger vessel was required to deal with an

increase in traffic. As *Ramsey* (1) was unsuitable for conversion to carry containers *Spaniel* was chartered from the Coast Lines Group. She was built in 1955 as *Brentfield* for the Zillah Shipping Company, and became *Spaniel* four years later. She was purchased by the Steam Packet in 1973 and was also adapted to carry forty-six TEUs and renamed *Conister* (2). *Ramsey* was put up for sale and purchased by R. Lapthorn & Co. of Rochester and renamed *Hoofort*, leaving Birkenhead on 9 January 1974. In 1982 she was sold to Cape Verde Island interests and renamed *Boa Entrado*.

A second car and passenger ferry, *Ben-my-Chree* (5), entered service on 12 May 1966 and was the last vessel to enter the fleet as a two-class ship as all the company's vessels were converted to one-class accommodation early in 1967. *Ben-my-Chree* (5) was a near sister of *Manx Maid* (2) and was also built at Birkenhead. However, she was laid up with the rest of the fleet soon after entering service because of the National Seaman's Strike. *Ben-my-Chree* (5) was left to operate the Liverpool–Douglas service single handed in April 1975 as *Manx Maid* was in dry-dock during an industrial dispute and *Mona's Queen* (5) was having her annual overhaul. *Ben-my-Chree* (5) was fitted with the ship's whistle from *Tynwald* (5) in 1978.

The carriage of cars increased from 6,000 in 1962 to 17,000 in 1971 and an order was placed for a third car and passenger ferry with the Ailsa Shipbuilding Co. at Troon. *Mona's Queen* (5) was delivered in 1973 and was the company's first motor ship. She cost £2,100,000 to build and was fitted with two 10-cylinder 10PC2V Crossley Pielstick engines, which produced 10,000 brake horsepower, driving variable pitch propellers. She operated the first car ferry voyage to Dublin in 1974 and the first from Fleetwood on 15 June 1976 with thirty-four cars and 800 passengers aboard. She made her final voyage for the company on 3 September 1990 and was laid up in Vittoria Dock, Birkenhead.

The fourth car and passenger ferry, *Lady of Mann* (2) was launched by the Ailsa Shipbuilding Co. on 4 December 1975 and she entered service on 30 June the following year from Douglas to Liverpool carrying sixty cars and 360 passengers. However, her late delivery meant that she missed most of the TT traffic. She was a near sister to *Mona's Queen* (5) with engines developing 11,500 BHP against the 10,000 BHP of her sister. The company were very pleased with her performance and on 15 August 1978 she completed the crossing from Fleetwood to Douglas in 2 hours 39 minutes and took one minute more the following day. On arrival of the *Seacat Isle of Man* she was laid up in Vittoria Dock Birkenhead with *Mona's Queen* (5) on 28 June 1994.

Geoff Duke and several other Manx businessmen set up the Manx line in 1978 to provide a roll on/roll off service to the Isle of Man. The motorship *Monte Castillo* arrived at Douglas on 23 March that year for trials and was then re-fitted at Leith and renamed *Manx Viking* in preparation to providing a new service from Heysham to Douglas. The first sailing on this service took place on 26 August 1978, but she suffered a broken piston on 8 September, and her sailings were suspended. The loss of revenue from the late delivery of the vessel, combined with the engine problems, meant that the company soon had to deal with serious financial problems. It was announced on 20 October that Sealink and James Fisher had taken over the line. On 1 December the linkspan at Douglas broke adrift in an easterly gale and the service from Heysham was suspended. It was sent to Harland & Wolff's yard at Belfast to be repaired.

Following a series of bad winter gales a decision was made to extend the breakwater at Douglas, to provide shelter to vessels while they were berthed in the harbour. An amount of

£7.2 million was approved to extend the Battery Pier. A temporary linkspan was installed at the north side of the King Edward Pier and *Manx Viking* resumed her sailings in May 1979 and a linkspan was later installed on the Victoria Pier in July that year for the Manx Line service. Following two years of losses the Steam Packet returned to profit in 1983.

The Steam Packet announced that they had placed an order for a linkspan in September 1980 and *NF Jaguar* was charted in 1981 to provide a roll on/roll off service to the island. The linkspan arrived and was positioned on the south Edward Pier on 3 June 1981 and the new service began on 19 June. *Peveril* (3) made her last sailing on 19 June and *Conister* (2) left Douglas on her final sailing two days earlier. *NF Jaguar* was renamed *Peveril* (4) in 1983. However, during 1984 the cargo services were severely disrupted by a series of strikes and several large customers transferred their business to the Sealink/ Manx Line.

On 27 July 1984, Sea Containers purchased Sealink from the British Government and Manx Line came under a new company, British Ferries Limited. The increases in the price of heavy grade oil were mostly responsible for the decision to withdraw the *Manx Maid* (2) and *Ben-my-Chree* (5) from service in 1984. They finished service in September that year and were advertised for sale the following month. The *Tamira* was purchased in October 1984. She had previously been owned by Townsend Thoreson as *Free Enterprise III*, and operated on English Channel services from Dover.

She sailed to the Clyde with a Steam Packet crew and was renamed *Mona's Isle* (6). The company finances were now showing a loss and there was little information on which mainland port they would be operating the new car and passenger ferry from. On 1 February 1985, a merger between Sealink and the Steam Packet was announced. It meant the end of the traditional Liverpool–Douglas service, with vessels sailing from Heysham to Douglas. The proposal was discussed at an Extraordinary General Meeting on 29 March and it was agreed to implement the merger from 1 April 1985. Sealink provided *Antrim Princess* on charter and she was renamed *Tynwald* (6). However, on 31 March, *Mona's Isle* (6) was still at Govan, *Peveril* (3) was strikebound in Liverpool, *Manx Viking*'s certificates were due to expire and the Port of Heysham was being blockaded by the crew of the *Stena Sailor*. *Lady of Mann* (2) and *Mona's Queen* (5) eventually sailed to Heysham on 3 April and when *Mona's Isle* (6) arrived from Govan she would not fit either linkspan at Douglas.

Mona's Isle's (6) maiden voyage was to Dun Laoghaire, where it became apparent that her bow thrust was inadequate and her engines were stuck in full astern while attempting to dock. *Manx Maid* (2) was sold in 1985 to be used as a nightclub at Bristol and her stabilizers were removed to be fitted to *Mona's Isle* (6). *Ben-my-Chree* (5) was sold to Mr D. B. Mulholland, who planned to use her as a restaurant ship in Jacksonville, Florida. *Mona's Queen* (5) took the final sailing from Liverpool on 30 March 1985. The berthing problems experienced with *Mona's Isle* (6) continued and tugs were provided at both Douglas and Heysham to assist her. When it was realised that the company were short of tonnage for the TT period it was decided to charter *Ben-my-Chree* (5), which was laid up at Birkenhead. She was in service from 25 May to 9 June on the Heysham–Douglas route. When she returned to lay up in Vittoria Dock it was announced that the sale to American interests had fallen through.

A decision was made in October 1985 to permanently withdraw the *Mona's Isle* (6) and she was sent to lay-up at Birkenhead. *Antrim Princess* joined *Manx Viking* on the Heysham service on 6 October and she became *Tynwald* (6), registered in Douglas at the end of the year. The Ardrossan sailings were transferred to Stranraer in 1986 and a limited number

of 'funboat' sailings were organised from Fleetwood to Douglas by Associated British Ports. Planning permission was refused for the proposal to base *Manx Maid* (2) at Bristol as a night club and she left Avonmouth under tow for Garston on 8 February 1986.

Mona's Isle (6) was sold to Saudi Arabian interests and was renamed *Al Fahad* at Birkenhead, where she was painted white. She sailed from the Mersey on 7 April 1986 for her new role in the Middle East. *Peveril* (4) completed her charter in April and was laid up at Birkenhead and it was announced that she would replace the *Manx Viking.* Her last sailing was on 29 September from Douglas to Heysham and following a union dispute she sailed to Barrow to be laid up. In the autumn of 1986 industrial action was taken by the National Union of Seamen over staffing levels on *Peveril* (3). *Manx Viking* was sold to Norwegian interests in February 1987 and renamed *Manx* and later *Skudenes.*

Mona's Queen (5) was overhauled at Douglas during the winter of 1987 and the crew of *Tynwald* (6) came out on strike on 29 December over pay and new proposed conditions of employment. The industrial action continued until 13 February, the following year. The crew of *Tynwald* (6) were involved in further industrial action in support of striking P&O seamen in April and May 1988. The Isle of Man Government chartered the *Bolette* from Fred Olsen Lines to deal with the TT traffic but she was not required.

Lady of Mann (2) received a £2.6 million renovation by Wright & Beyer Ltd at Birkenhead early in 1989. The work involved replanning and upgrading the passenger accommodation and providing additional car space for fifty vehicles. She returned to service on 26 May with a revised tonnage of 3,083 grt and a revised capacity of 1,000 passengers. On 14 July 1989, *Peveril* (4) suffered an engine malfunction and collided with the linkspan at Douglas causing damage to the ramp, which was later towed to Birkenhead for repairs.

On 16 August 1989, the Rea tug *Hollygarth* towed *Ben-my-Chree* (5) to Santander to be broken up. *Mona's Queen* (5) undertook a charter by the French post office at the end of August 1989 and on 3 September she was chartered to Sealink on the Portsmouth–Channel Islands route and later on their Weymouth service. The Douglas–Stranraer service was withdrawn in August 1989 and the repaired linkspan arrived back at Douglas from the Mersey.

The *Channel Entente* was purchased early in 1990 and was overhauled on the Mersey and berthed in Bidston Dock, Birkenhead, in preparation for her introduction to the Manx routes. *Tynwald* (6) was returned to Sealink and sailed to Belfast from Douglas and then to be laid up on the River Fal. She was sold to Agostino Lauro of Naples, sailing from Falmouth on 25 May as *Lauro Express. Mona's Queen* (5) was withdrawn from service on 3 September 1990 and was laid up in Vittoria Dock at Birkenhead. *Channel Entente* undertook a major overhaul at Birkenhead at the end of 1990 and a side door was fitted to her so that she could load and unload vehicles at Liverpool Landing Stage. On 8 December she was renamed *King Orry* (5) at Douglas.

Manxman (2) was towed back to Liverpool on 5 November 1990 when her berth at Preston was required for the development of the dock. She docked at Waterloo Dock the following day and was later renamed *Manxman Princess.* Seacat *Hoverspeed Great Britain* berthed at Douglas on 5 November and operated a trial trip to Heysham the following day. The service from Douglas to Liverpool restarted after a gap of five years on 12 January 1991 when *Lady of Mann* (2) took the return sailing. *Lady of Mann* (2) operated a sailing from Fleetwood to Douglas on 24 May 1992 to mark the 150th anniversary of the *Mona's Isle* on 31 May 1842.

Shortly after leaving Liverpool on 14 November, *King Orry* (5) suffered a steering failure in the Queen's Channel and went aground. She was re-floated with the help of the Bramley-Moore and Hollygarth and towed back to Liverpool Landing Stage.

Peveril (4) was purchased from James Fisher & Sons in 1993 and on 2 June that year *Lady of Mann* (2) collided with the Battery Pier and sustained damage to her bow. Unfortunately, the accident occurred during the busy TT period and it was arranged for Caledonian MacBrayne's *Pioneer* to operate a sailing from Gourock to Douglas and SeaCat Scotland sailed from Stranraer to the island on 3 June with motorcyclists. *Lady of Mann* (2) returned into service on 4 June. A new freight service which was a wholly owned subsidiary of the Steam Packet was inaugurated. P&O's *Belard* was chartered for this service.

On 11 March 1994, the Steam Packet announced that a SeaCat would be operating on Irish Sea services that summer and *Lady of Mann* (2) would be withdrawn. *Manxman* (2) was on the move again when she was towed from Liverpool to Hull on 16 April for use as a nightclub. From the end of May to September *Claymore* operated a limited service from Ardrossan to Douglas and *Lady of Mann* (2) made her final passenger sailing from Liverpool to Douglas on 27 June. The following morning she left her berth at Victoria Pier to be laid up in Vittoria Dock at Birkenhead.

Soon after the '*Lady*' had sailed for the Mersey *SeaCat Isle of Man* sailed on her maiden voyage to Fleetwood, passing *King Orry* (5) in the Irish Sea on her voyage from Douglas to Heysham. However, a mooring rope fouled one of *SeaCat Isle of Man*'s waterjets and passengers for the return journey to the Island were transferred to the *King Orry* (5) at Heysham. *Belard* was purchased for £3.2 million by the Steam Packet on August 1994 and work commenced on a new linkspan at the Edward Pier at Douglas.

During her overhaul in the winter of 1994/95 *King Orry* was registered at Douglas and *Lady of Mann* was chartered to the Porto Santo Line of Madeira. Following the 1995 TT races she left Birkenhead on 17 July for the voyage to Funchal, Madeira. A new ten year 'User Agreement' was approved by the Manx Government, with the Steam Packet agreeing to operate a minimum number of sailings a year to north-west England and Irish ports. Freight sailings were to be provided for at least five days a week and a limited service on the sixth. The agreement also covered the investment in vessels, fare increases and the Steam Packet were then given the sole rights to the linkspan.

On 27 September 1995, *SeaCat Isle of Man* was damaged by a wave near the Mersey Bar and went to Cammell Laird for repairs to be carried out on her watertight bow visor. It was announced at the end of October that *SeaCat Isle of Man* would not be operating on Steam Packet service the following year. *Lady of Mann* (2) returned from Madeira in November and *Mona's Queen* (5) was sold to the Philippines and renamed *Mary the Queen*.

Sea Containers Isle of Man announced on 29 March 1996 that they now owned 58 per cent of the shares in the Steam Packet and by May that year they controlled over 95 per cent of the shares. An order was placed for a ro-pax vessel with Van der Giessen-de-Noord early in 1997. This ship would replace *King Orry* (5) and *Peveril* (4). *SeaCat Isle of Man* returned to Steam Packet services in 1997 and *Lady of Mann* was placed on a Fleetwood to Dublin service, which was later transferred to operate from Liverpool. The keel was laid of the new vessel on 28 October 1997.

SeaCat Danmark was operating on Manx services during the 1998 season and *Lady of Mann* (2) departed to the Azores on 17 June, on charter for three months. *SuperSeaCat Two*

took over the Liverpool to Dublin service in 1998 and experienced several technical and weather related cancellations. The new *Ben-my-Chree* (5) arrived at Douglas on 6 July 1998 and entered a full passenger service on 4 August. *King Orry* (5) was laid up in Vittoria Dock at Birkenhead and was soon sold to Moby Lines of Italy. She sailed from Birkenhead on 23 October under the name *Moby Love*.

The size of the *Ben-my-Chree*'s (5) passenger accommodation was regularly criticised in the Manx press and the Manx Parliament appointed a Committee to look at the frequency and quality of services provided to the Isle of Man. The Steam Packet later announced that *Ben-my-Chree's* passenger capacity would be reduced to 350 in the future. *SeaCat Isle of Man* was again operating for the Steam Packet in 1999 and *Lady of Mann* (2) carried out a day excursion on 26 May from Llandudno to Douglas with 900 passengers, and the following day she brought 600 people from Fleetwood to the island for the day. When the *Lady of Mann* (2) had completed her TT sailings she returned to dock on 23 July and was able to cover for the fast-craft on the Liverpool and Dublin sailings when the weather prevented them from sailing.

Ben-my-Chree (5), *Lady of Mann* (2), *SuperSeaCat Two*, *SuperSeaCat Three*, *SeaCat Isle of Man* and *SeaCat Scotland* were all used on Manx services during 2000. *Lady of Mann* (2) was again sent to the Azores for another three-month charter and on return she provided cover on the Liverpool–Douglas winter services. She arrived at Cammell Laird's yard in February 2001 for her overhaul and also for SOLAS upgrading work to be carried out. The Manx Government took the decision to cancel the TT Races in 2001 because of the outbreak of foot and mouth disease and the *Lady of Mann* (2) again carried out another charter in the Azores for the Acor Line.

A new five-year extension was granted to the Steam Packet by the Manx Government in 2002 and *Lady of Mann* (2) provided extra sailings when *Ben-my-Chree* (5) was required to have emergency repairs carried out during the busy period of 28 and 29 May. The company was taken over by Montagu Private Equity in 2003, who purchased it from Sea Containers for £142 million. *Ben-my-Chree* (5) undertook an extensive £1.5 million overhaul later that year at Birkenhead, where her passenger capacity was increased to 500, and a new Quiet lounge and bar were built aft of her funnel.

Ben-my-Chree (5), *Lady of Mann* (2), *SuperSeaCat Two* and *Rapide* provided the majority of sailings during the 2004 TT period and *Lady of Mann* (2) sailed to the Azores for another charter. The Steam Packet announced in 2004 that they would no longer operate the Liverpool –Dublin route and that *SuperSeaCat Two* would be transferred to the Manx services and that *SeaCat Isle of Man* would be available for charter. She was acquired by Irish Sea Express in 2005 and operated on a new service from Liverpool to Dublin. However, the service was not a success and when it was terminated after six months in operation the vessel was laid up at Birkenhead. The Steam Packet was taken over by the Australian Macquarie Bank for £225 million in 2005.

The *Lady of Mann* (2) was sold in 2005 and sailed from Liverpool in October under the name *Panagia Soumela*. She was converted to a stern loading vessel at Piraeus over the following winter and commenced service for SAOS Ferries on the Lavrion–Limnos route. She was briefly laid up in December, 2008 but was brought back to service during 2009. *Panagia Soumela* was broken up at Aliaga in 2011.

On 3 February 2007, *Sea Express 1* was preparing to berth at Liverpool Landing Stage in low visibility at the end of a voyage from Douglas, and she collided with the cargo

vessel *Alaska Rainbow*, which was attempting to enter Alfred Dock, Birkenhead. Several tugs came to the rescue and *Sea Express 1* was assisted to the stage, where her passengers were discharged. As she had been holed the tugs used their pumps to keep her afloat. They remained with her and assisted her into Cammell Laird's wet basin the following day. The Steam Packet had originally planned to operate her on the 2007 summer sailings but were forced to charter *Emeraude France* which was laid up at Tilbury.

Although her engine room had been flooded it was decided to have her repaired and she was renamed *Snaefell* (6) in 2007. The renaming was part of a rebranding of the company which was intended to 'return to the classic livery and promote the Island's culture'. *SuperSeaCat Two* was also renamed as *Viking* (2). The ships received a new livery with internal refits reflecting the company's new colours. The terminals at the ports used by the Steam Packet also received new signage.

Manannan was purchased as *Incat 050* from Incat at Tasmania. She is a 96-metre wave-piercing, high-speed catamaran and was built in 1998. She initially operated as a ferry under the name of *Devil Cat* and *Top Cat* until she was acquired by the United States Navy to evaluate the use of high speed ferries in service in 2001. She became USS *Joint Venture* and was fitted with a flight deck to enable helicopters to land on her and could also carry large numbers of personnel at over 40 knots. At the end of her five year charter she was handed back to Incat and when a charter to operate in Mexico was cancelled she was purchased by the Steam Packet. A Manx crew sailed her back from Tasmania, via the Suez Canal to Portsmouth, where she received a £3 million refit and major conversion by Burgess Marine. She arrived at Douglas on 11 May 2009, was renamed *Manannan* and sailed on her maiden voyage to Liverpool on 22 May. *Viking* (2) was sold to the Atlantico Line in 2009 and has since been renamed *Hellenic Wind*.

As she was disembarking passengers at Heysham on 26 March 2010, *Ben-my-Chree* (6) moved about eight metres, causing damage to the passenger walkway, which collapsed onto the quayside. There were no injuries but some passengers who were in the structure were later rescued by fire fighters. In July 2010, *Manannan* suffered a technical problem and several weeks later *Snaefell* (6) was also affected. They were unable to maintain the published timetable until the issue was resolved. One of *Manannan's* gearboxes also caused problems in July 2011 and this was particularly disappointing as all four gearboxes had been overhauled during the winter of 2010. *Snaefell* left the Mersey for Greece in June 2011 and it was rumoured that she was chartered by NEL Lines as *Cyclades Express* had suffered an engine room fire. However, she was later renamed *Master Jet*, registered in Cyprus.

Mezeron set up a freight service from Liverpool to Douglas in 2010 to rival the Steam Packet's operations. It initially attracted some of the company's main customers and Mark Woodward, the Steam Packet Chief Executive, stated that the competition was bad news for the Isle of Man and that it may cause a rise in passenger fares and freight rates or a reduction in passenger services. Mezeron later announced that the service provided by them from Liverpool would cease to operate from 19 February 2011.

Early in April 2011 it was announced that the Isle of Man Steam Packet had changed hands as part of a refinancing deal and that Macquarie ceased to have any stake in the company. All of their holdings were transferred to the new owners, who were a group of banks led by Banco Espirito Santo, which provide the company's new funding arrangements and control the Isle of Man-based holding company, Sealion (Isle of Man) Ltd.

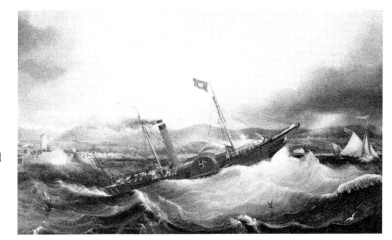

Mona's Isle,
1830, 200grt,
35.36mx5.79m,
8½ kt, b. John Wood
& Co., Port Glasgow.
Engines by Robert
Napier, Glasgow.
Sold in 1851 and
broken up.

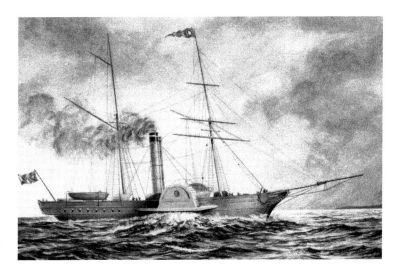

King Orry (1),
1842, 433grt,
42.67mx7.09m,
9½ kt, b. John
Winram, Douglas.
Engines by Robert
Napier, Glasgow.
Accepted as £5,000
part payment in
1858 for *Douglas*
(1). Re-sold to Greek
interests.

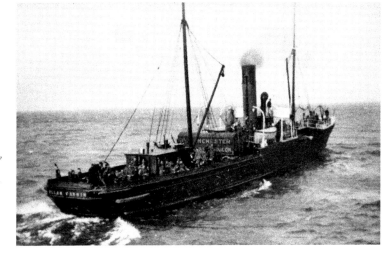

Mona's Isle (2)
/ *Ellan Vannin*
(1), 1860, 339grt,
63.09mx6.71m, 12 kt,
b. Tod & McGregor,
Glasgow. Engines by
builder. Foundered
near Mersey Bar, 3
December 1909,all
on board were lost.

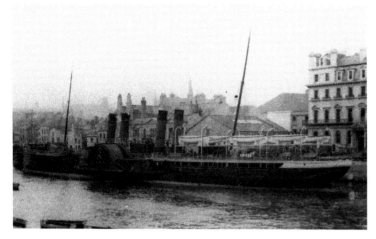

Ben-my-Chree (2), 1875, 1,030grt, 96.93mx9.45m, 14kt, b. Barrow Shipbuilding Co. Ltd. Engines by builder. Broken up at Morecambe by T. W. Ward & Co. in 1906.

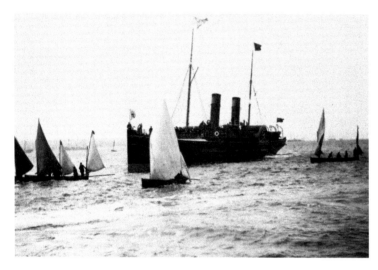

King Orry (2), 1871 809grt, 79.25x8.94m, 15kt, b. R. Duncan & Co., Port Glasgow. Engines by Rankin & Blackmore, Greenock. 1888, refitted by Westray, Copeland & Co., Barrow, lengthened by 9.14m. New compound diagonal engines, speed 17 knots. Broken up at Llanerch-y-Mor in 1912.

Fenella (1), 1881, 564grt, 63.09mx7.92m, 14kt, b. Barrow Shipbuilding Co. Ltd. Engines by builder. Broken up by John Cashmore at Newport in 1929.

Mona's Isle (3), 1882, 1,564grt, 103.02mx11.58m, 18kt, b. Caird & Co., Greenock. Engines by builder. Purchased by the Admiralty in 1915 and was broken up at Morecambe by T. W. Ward Ltd in 1919.

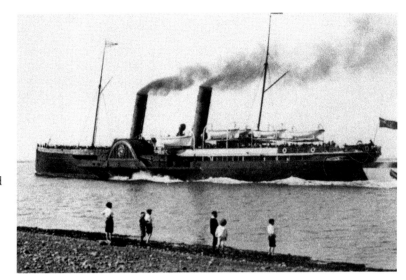

Prince of Wales (1), 1887, 1,657grt, 104.09mx11.89m, 20¼ kt, b. Fairfield Shipbuilding & Engineering Co. Ltd, Govan. Engines by builder. Purchased by Admiralty in 1915, renamed *Prince Edward* and broken up in Holland in 1920.

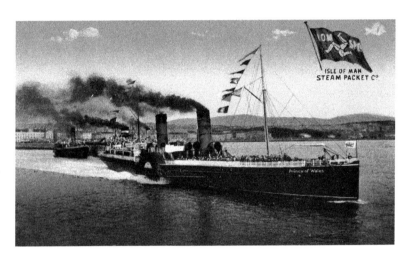

Queen Victoria (1), 1887, 1,657grt, 104.09mx11.89m, 20¼ kt, b. Fairfield Shipbuilding & Engineering Co. Ltd, Govan. Engines by builder. Purchased by the Admiralty in 1915 and was broken up in Holland in 1920.

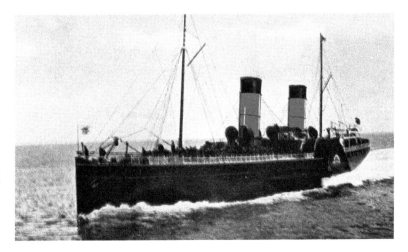

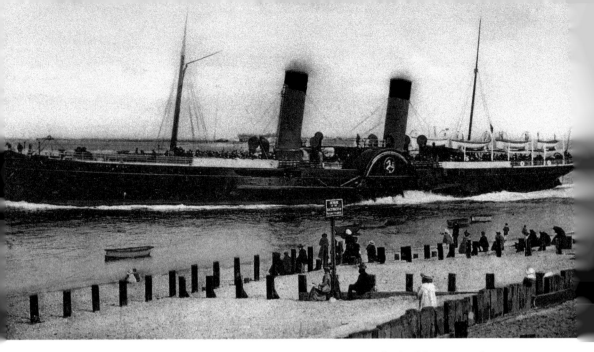

Mona's Queen (2), 1885, 1,559grt, 99.98mx11.66m, 19kt, b. Barrow Shipbuilding Co. Ltd. Engines by builder. She was broken up by Smith & Houston at Port Glasgow in 1929.

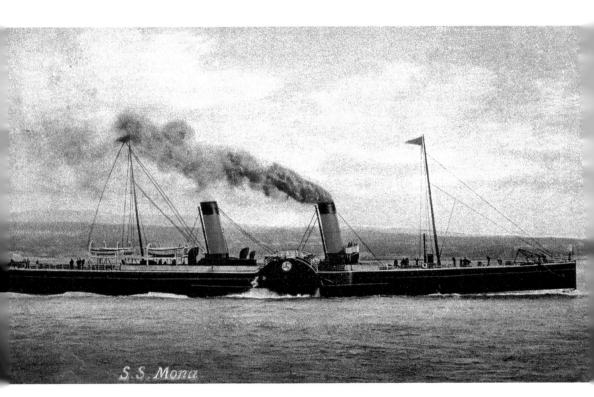

Mona (3), 1889, 1,212grt, 102.41mx10.97m, 18kt, b. Fairfield Shipbuilding & Engineering Co. Ltd, Govan. Engines by builder. She was broken up by T. W. Ward Ltd at Briton Ferry in 1909.

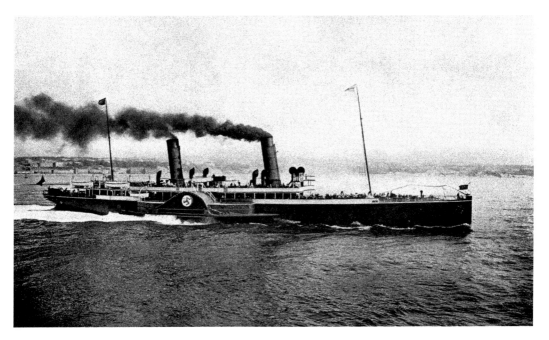

Empress Queen, 1897, 2,140grt, 113.39mx13.11m, 21½ kt, b. Fairfield Shipbuilding & Engineering Co. Ltd. Engines by builder. Taken over by the Admiralty in 1915. Stranded on Bembridge Ledge, Isle of Wight on 1 February 1916. Declared a total loss.

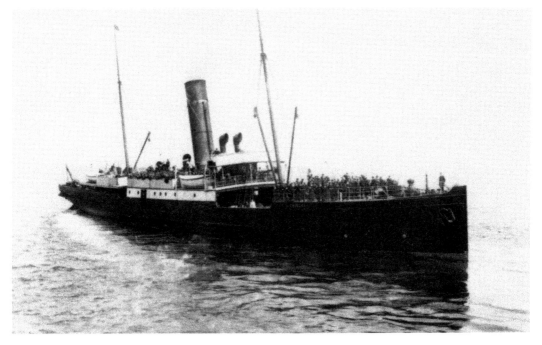

Douglas (3), 1889, 774grt, 75.89mx9.14m 15kt, b. Robert Napier, Glasgow. Engines by builder. Sank in the River Mersey, following a collision with *Artemisia* on 16 August 1923.

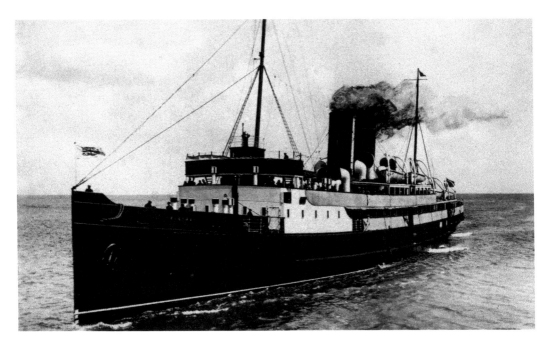

Manxman (1), 1904, 2,030grt, 103.94mx13.11m, 22kt, b. Vickers, Sons & Maxim, Barrow. Engines by builder. Built as *Manxman* for the Midland Railway and acquired by the IOMSPC in March 1920. She was requisitioned by the Admiralty in 1939 and broken up by T. W. Ward at Preston in 1949.

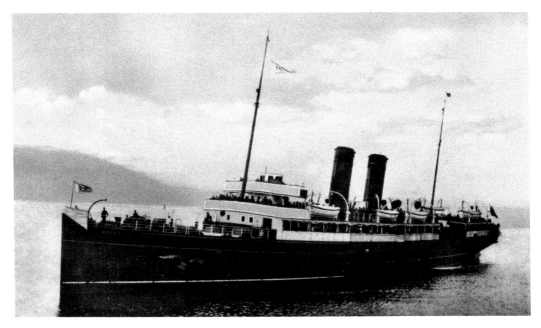

Mona's Isle (4), 1905, 1,691grt. 96.93mx12.19m, 21kt, b. William Denny & Brothers, Dumbarton. Engines by builder. Sold in 1948 and broken up at Milford Haven.

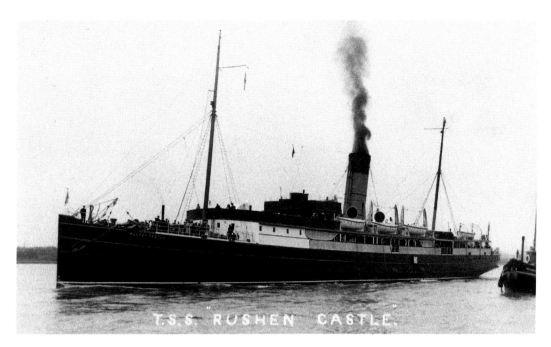

Rushen Castle (1), 1898, 1,724grt, 97.84mx11.28m, 17½ kt, b. Vickers, Sons and Maxim Ltd, Barrow. Built as *Duke of Cornwall* for the Lancashire & Yorkshire and London & North Western Railway Joint Service. Acquired by the IOMSPC on 11 May 1928. She was sold for demolition in Ghent and was towed from Douglas on 9 January 1947 by the *Ganges*.

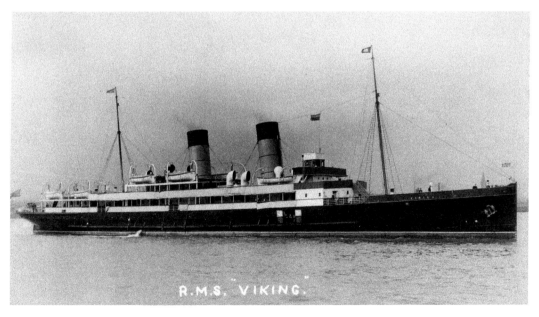

Viking (1), 1905, 1,957grt, 110.03x12.80m, 22½ kt, b. Armstrong, Whitworth & Co., Newcastle. Engines by Parsons Marine Steam Turbine Co. Ltd. Broken up at Barrow by T. W. Ward in 1954.

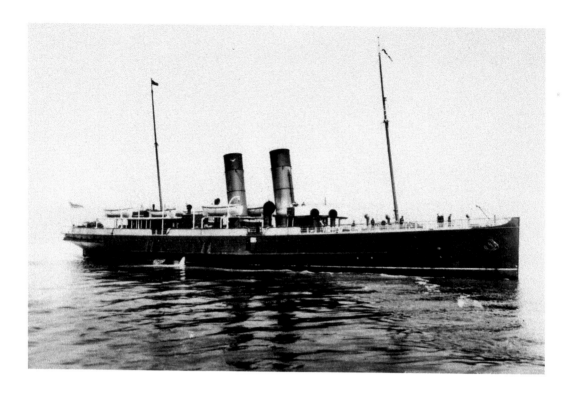

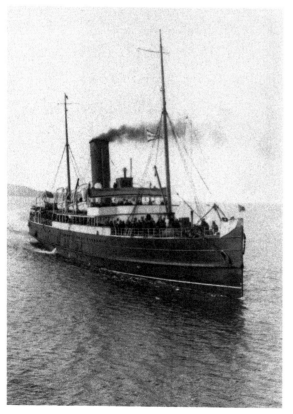

Above: Tynwald (3), 1891, 937grt, 84.12mx10.36m, 18kt, b. Fairfield Shipbuilding & Engineering Co. Ltd, Govan. Engines by builder. Laid up in 1930 and sold to R. A. Colby Cubbin in 1933 and renamed *Western Isles*. Requisitioned by the Admiralty in 1939, renamed *Eastern Isles*. Broken up at La Spezia in 1952.

Left: Peel Castle (1), 1894, 1,474grt, 97.84mx11.28m, 17½ kt, b. William Denny & Bros, Dumbarton. Engines by builder. Built as *Duke of York* for the Lancashire & Yorkshire Railway and purchased by the IOMSPC in 1912. Broken up by Arnott Young at Dalmuir in 1939.

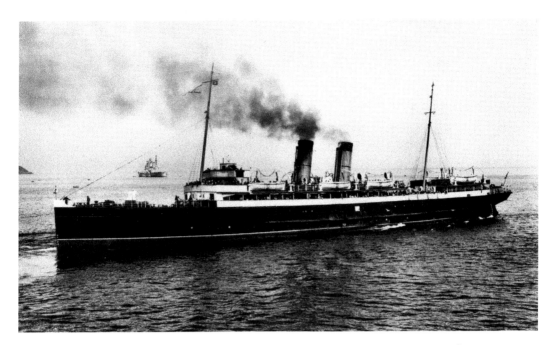

Victoria (1), 1907, 1,641grt, 98.15mx12.19m, 21kt, b. William Denny & Bros, Dumbarton. Engines by builder. Built as *Victoria* for the South Eastern & Chatham Railway. Purchased by the IOMSPC in 1928. Laid up at Birkenhead in 1956 and towed to Barrow on 25 January 1957 and broken up by T. W. Ward.

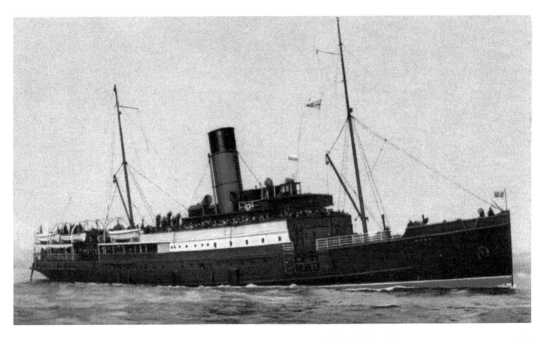

Mona (4), 1907, 1,219grt, 81.69mx10.97m, 16kt, b. Fairfield Shipbuilding & Engineering Co. Ltd, Govan. Engines by builder. Built as *Hazel* for the Laird Line and purchased by the IOMSPC in 1919. Broken up at Llanelli by E. G. Rees in 1938/39.

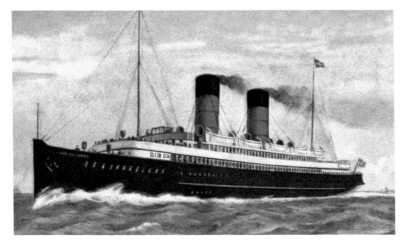

Ben-my-Chree (3),
1908, 1,368grt,
118.57mx14.02m,
24½ kt, b.
Vickers, Sons &
Maxim, Barrow.
Engines by
builder. Sunk at
Castellorizo on
11 January 1917.
Raised in 1920
and broken up at
Venice in 1923.

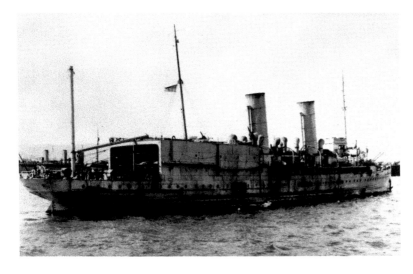

Ben-my-Chree (3).

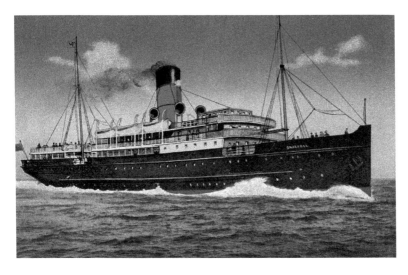

Snaefell (3),
1910, 1,368grt,
85.95mx12.60m,
19kt, b. Cammell
Laird & Co. Ltd,
Birkenhead.
Engines
by builder.
Requisitioned by
the Admiralty in
1914, torpedoed
and sunk in the
Mediterranean
on 5 June 1918.

Manx Maid (1), 1910, 1,504grt, 90.83mx11.89m, 20kt, b. Cammell Laird & Co. Ltd, Birkenhead. Engines by builder. Built as *Caesarea* for the London & South Western Railway and purchased by the IOMSPC in 1923. She was broken up by T. W. Ward at Barrow in 1950.

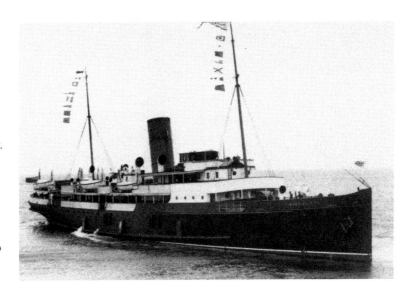

King Orry (3), 1913, 1,877grt, 95.40mx13.11m, 20¾ kt, b. Cammell Laird & Co. Ltd, Birkenhead. Engines by builder. Sunk after being bombed at the evacuation of Dunkirk on 30 May 1940.

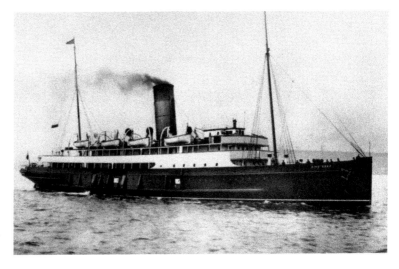

King Orry (3) in line with the British fleet at the surrender of the German Navy at 9.30 a.m. on 22 November 1918.

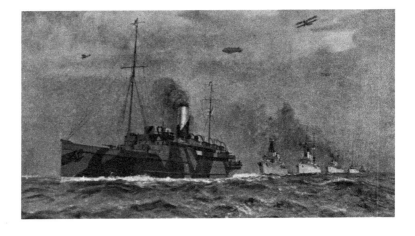

31

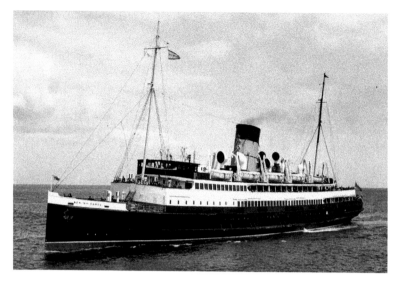

Ben-my-Chree (4), 1927, 2,586grt, 111.56mx14.02m, 22½ kt, b. Cammell Laird & Co. Ltd, Birkenhead. Engines by builder. Renamed Ben my Chree II, sold and broken up in Ghent in 1965/66.

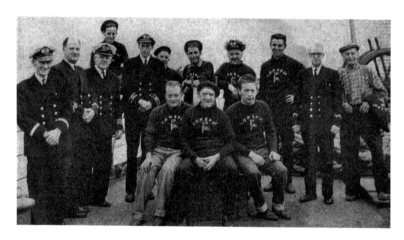

The officers and crew of Ben-my-Chree (4) prior to her last commercial voyage on 13 September 1965.

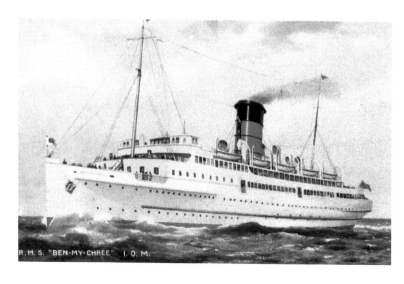

Ben-my-Chree (4) was pained with a white hull in 1932.

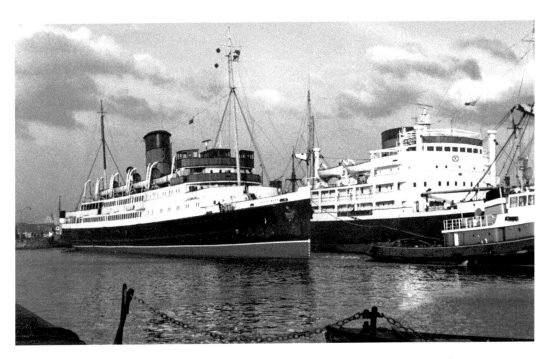

Lady of Mann (1) in Alfred Dock, Birkenhead prior to the summer season in 1965.

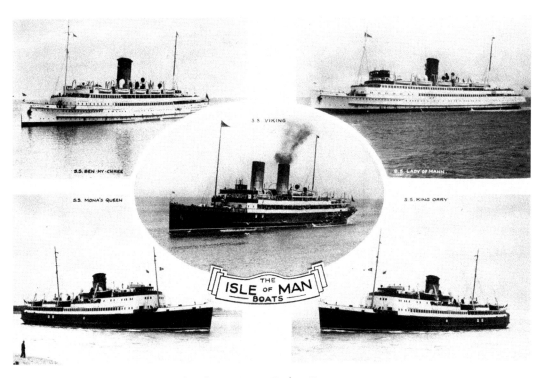

Postcard of vessels of the Isle of Man Steam Packet Co.

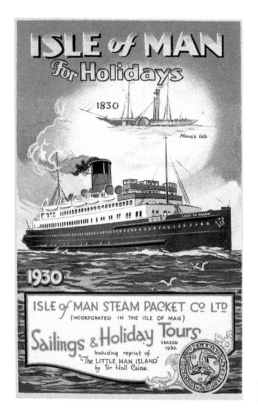

1930s posters for Isle of Man holidays by the
Isle of Man Steam Packet.

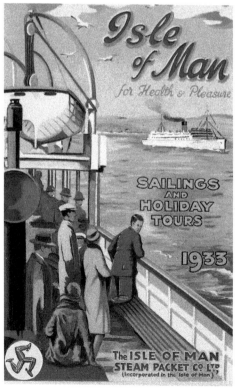

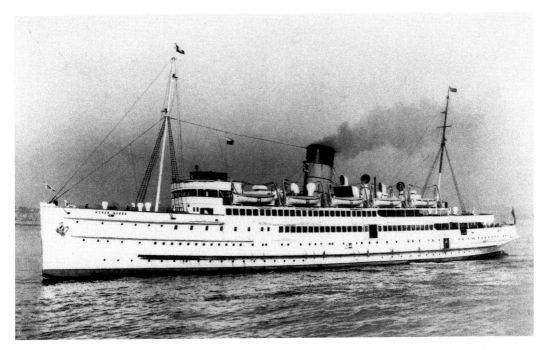

Mona's Queen (3), 1934, 2,756grt, 106.68mx14.63m, 21½ kt, b. Cammell Laird & Co. Ltd, Birkenhead. Engines by builder. Mined and sunk at Dunkirk on 29 May 1940.

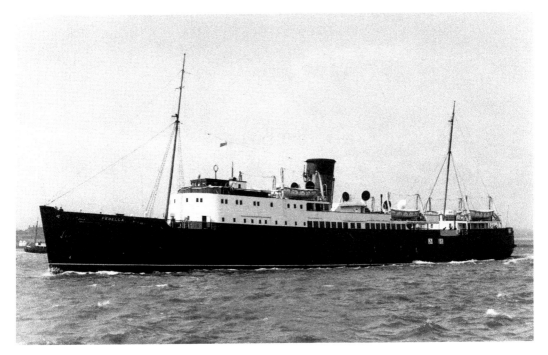

Tynwald (4), 1937, 2,376grt, 95.86mx14.02m, 21kt, b. Vickers Armstrong Ltd, Barrow. Engines by builder. Torpedoed and sunk at Bougie, Algeria, on 12 November 1942.

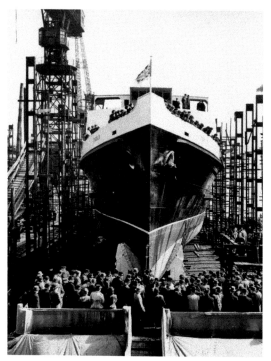

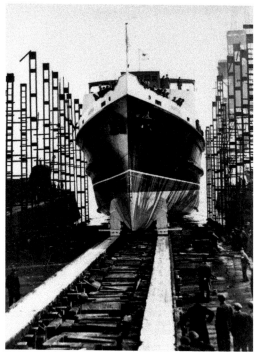

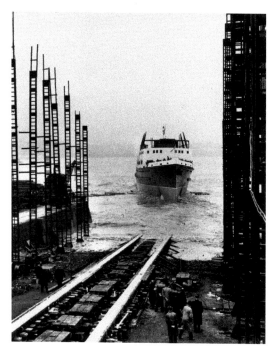

Above left: Launch of *Tynwald* (5) at the yard of Cammell Laird & Co., Birkenhead, on 24 March 1947.

Above right: Following her launch *Snaefell* (5) enters the Mersey on 11 March 1948.

Right: *Manxman* (2) in the Mersey, following her launch by Cammell Laird & Co. Ltd on 8 February 1955.

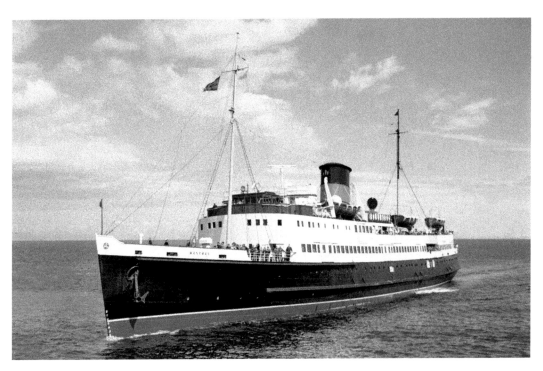

Manxman (2), 1955, 2,495grt, 105.11mx15.24m, 21½ kt. *Manxman* is shown here arriving at Douglas on a voyage from Liverpool in 1967.

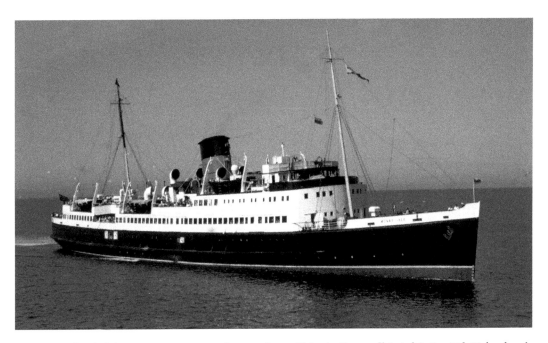

Mona's Isle (5), 1951, 2,491grt, 105.16mx14.38m, 21½ kt, b. Cammell Laird & Co. Ltd, Birkenhead. Engines by builder. Sold and left Birkenhead under tow of *Afon Wen* on 30 October 1980 be broken up in Holland.

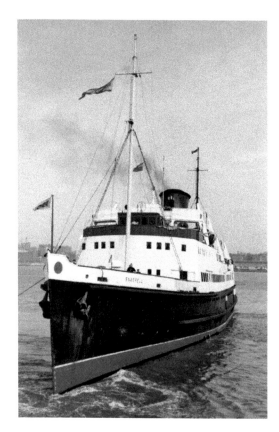

Left: *Snaefell* (5), 1948, 2,489grt, 105.11mx14.38m, 21½ kt. Sold to Rochdale Metal Recovery Co. and towed by *George V* to Blyth on 24 August 1978 to be broken up by H. Kitson, Vickers & Co..

Below: *Manxman* (2) making black smoke in the River Mersey in 1968.

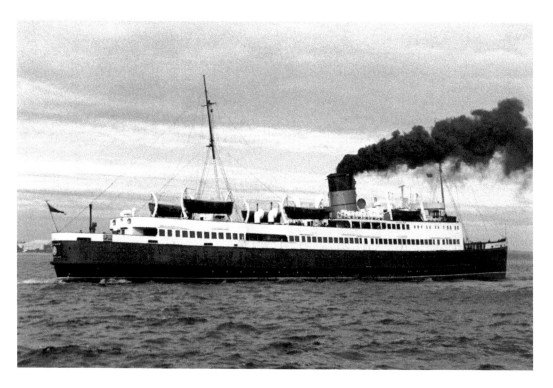

Above: Mona's Isle (5) in dry-dock at Birkenhead following her grounding at Peel on 15 February 1964. She was towed back to the Mersey by the Alexandra tugs, *North End* and *North Wall. Mona's Isle* did not return to service until 14 July that year.

Right: Manx Maid (2), 1962, 2,724grt, 104.83mx16.16m, 21½ kt, b. Cammell Laird & Co. Ltd, Birkenhead. Engines by builder. She was the Isle of Man Steam Packet Co.'s first car ferry and is shown entering Alfred Dock, Birkenhead.

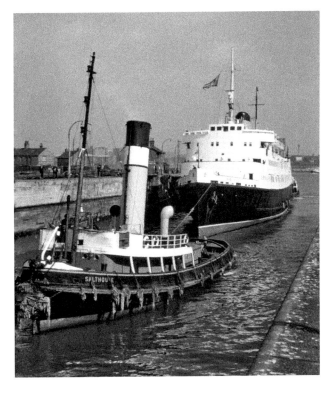

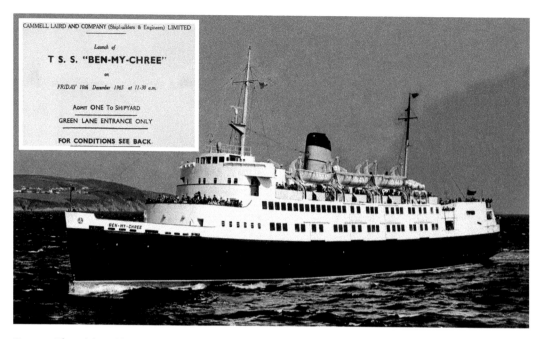

Ben-my-Chree (5), 1966, 2,762grt, 104.83mx16.13m, 21½ kt, b. Cammell Laird & Co. Ltd, Birkenhead. Engines by builder. Sold for use as a restaurant ship in Jacksonville, Florida, in 1985, and was chartered back to the Steam Packet between 25 May and 10 June that year. Left Birkenhead under tow of *Hollygarth* on 16 August 1989 to be broken up at Santander.

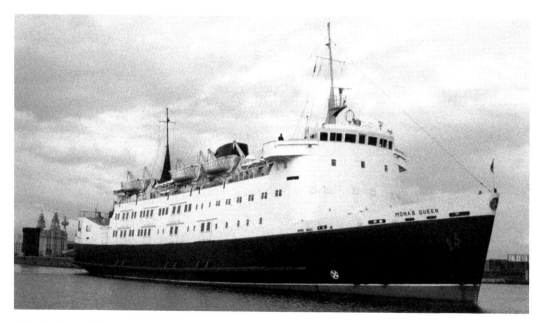

Mona's Queen (5), 1973, 2,998grt, 104.45mx16.74m, 21kt, b. Ailsa Shipbuilding Co. Ltd, Troon. Engines by builder. Following the summer season she was laid up at Birkenhead in 1990 and sold to MBRS Line, Manila, Philippines, in November 1994 and renamed *Mary the Queen*. She was broken up at Alang in 2008.

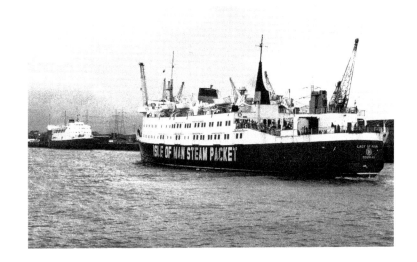

Lady of Mann (2) (right and above), 1976, 2,990grt (3,083grt in 1989), 104.43mx16.74m, 21kt, b. Ailsa Shipbuilding Co. Ltd, Troon.

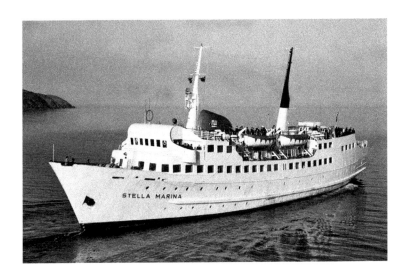

Stella Marina was advertised as offering 'Luxury Mini Cruises' from Fleetwood to the Isle of Man in 1969. She departed Fleetwood at 10.30, arriving at Douglas at 14.00. She left the Isle of Man on the return journey at 18.00 arriving at Fleetwood at 21.30.

Manx Viking (1976/3,589grt) arriving at Douglas and (below) in a later livery at Birkenhead following a major overhaul. She operated on the Heysham-Douglas service from 1978 to 1986.

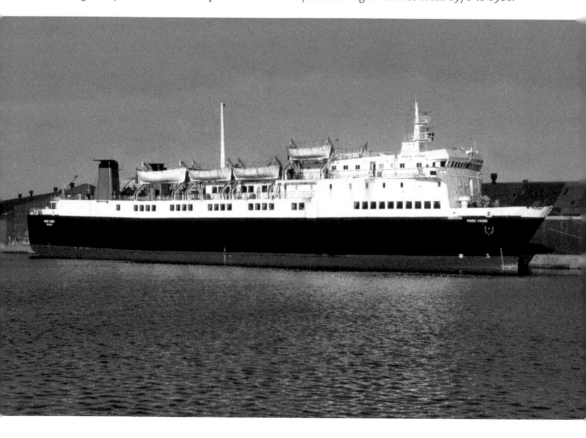

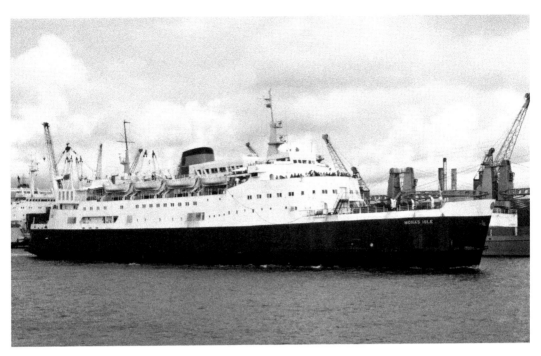

Mona's Isle (6) was built as *Free Enterprise III* for Townsend Car Ferries, later Townsend-Thoresen, and was employed on routes from Dover. She was purchased by the Steam Packet and sailed on her maiden voyage on the Heysham–Douglas route on 5 April 1985. Her final voyage took place on 5 October 1985 and she was sold, becoming *Al Fahad*.

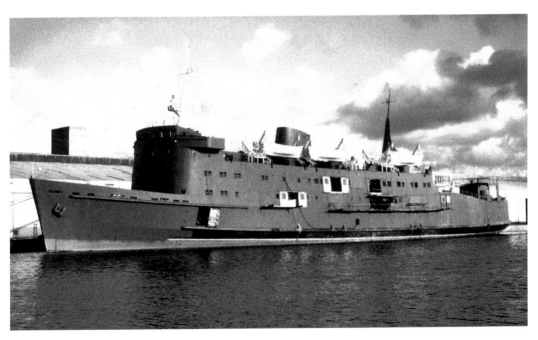

Lady of Mann (2) in Vittoria Dock in 1989 during her £2.6 million renovation.

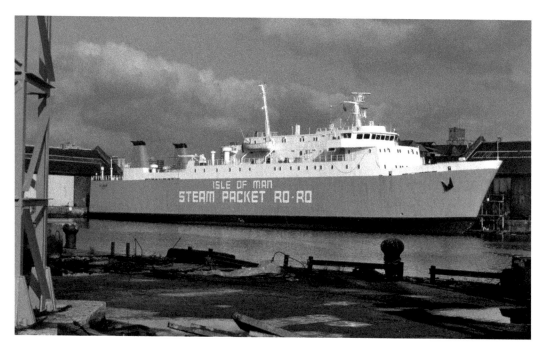

Peveril (4) in her original and later (below) livery. She was built as *Holmia* for Silja Line in 1971, becoming *ASD Meteor* in 1973 and *Penda* until 1980 when she was renamed *NF Jaguar*. She was bareboat chartered to the Steam Packet in 1981 and was purchased by James Fisher the following year. In 1993 she was purchased by the Isle of Man Steam Packet and was employed on the cargo service until 1998 when she was laid up at Vittoria Dock, Birkenhead. Renamed *Caribbean Express* in 2000, when she was purchased by Marine Express Incorporated of Puerto Rico. She sailed from Birkenhead on 27 September that year.

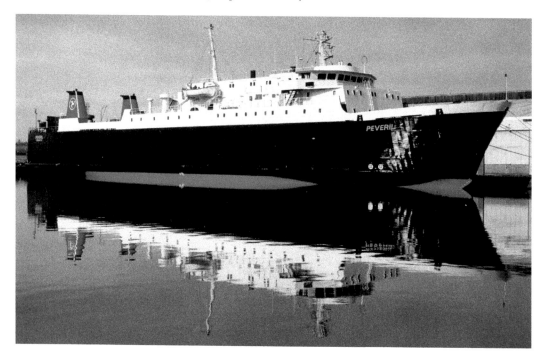

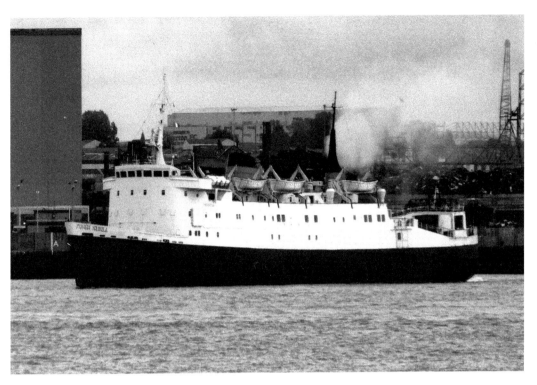

Panagia Soumela (ex-*Lady of Mann*) sails from Langton Dock, Liverpool in October 2005.

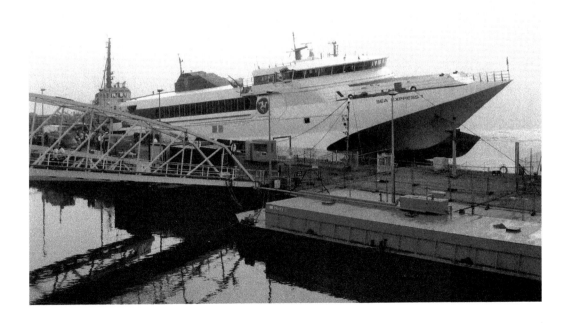

Sea Express I (ex-*SeaCat Isle of Man*) following her collision with *Alaska Rainbow* on 3 February 2007.

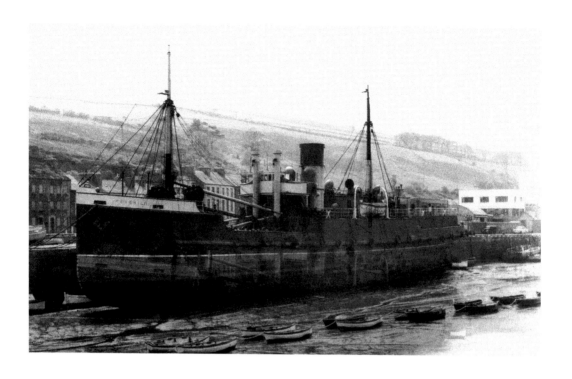

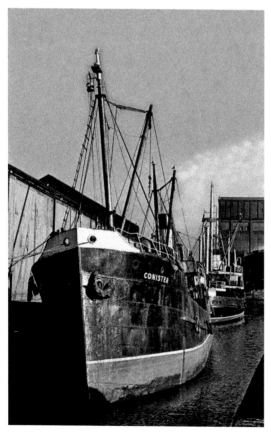

Peveril (2), 1929, 798grt, 64.92mx10.52m, 12kt, b. Vickers Armstrong Ltd, Barrow. Engines by builder. Laid up at Douglas in 1964, she was broken up at Glasson Dock later that year.

Conister (1) 1921, 411grt, 44.20mx7.31m, 10kt, b. Goole Shipbuilding Co. Ltd, Goole. Engines by builder. Built as *Abington* for G. T. Gillie & Blair, Newcastle, and purchased by the Steam Packet in 1932. Left Douglas on 26 January 1965 to be broken up by Arnott Young at Dalmuir.

Snaefell (5) arrives at Ramsey Pier in 1962.

Tynwald (5) in the summer season of 1967 on the Liverpool–Douglas service.

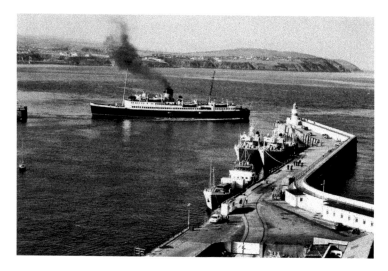

Snaefell (5) moves astern from Victoria Pier on a late afternoon voyage to Liverpool.

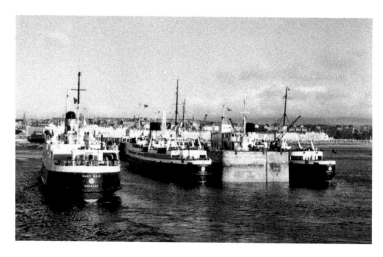

Manx Maid (2) passes *King Orry* (4) as she enters Douglas Harbour. *Tynwald* (5) loads passengers and motor cycles at the end of Victoria Pier.

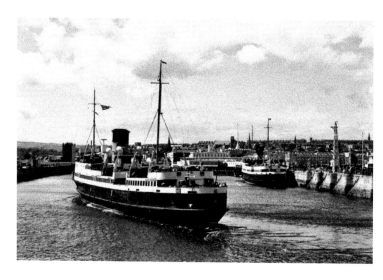

Mona's Isle (5) arrives at Douglas from Llandudno as *Manxman* (2) loads at Victoria Pier.

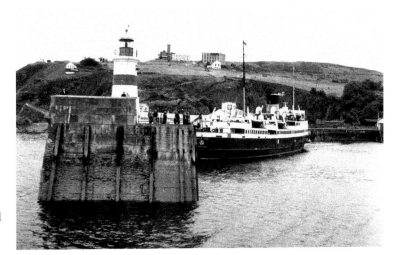

Mona's Isle (5) is laid up at the Battery Pier.

The cargo vessels *Ramsey* (1965/446grt), *Peveril* (1964/1,048grt) and *Fenella* (1951/1,019grt) at the Steam Packet's berth in Coburg Dock, Liverpool.

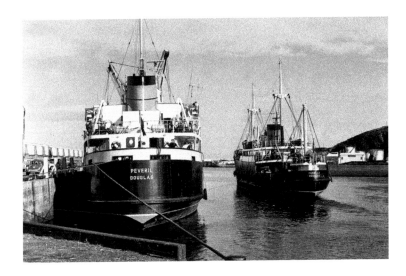

Fenella (1951/1,019grt) passes *Peveril* (1964/1,048grt) in Douglas Harbour.

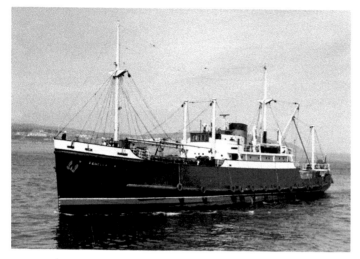

Fenella (3), 1951, 1,019grt, 64.01mx11.28m, 12½ kt, b. Ailsa Shipbuilding Co. Ltd, Troon. Engines by builder. Purchased by Juliet Shipping Co., renamed *Vasso M* and sailed from Birkenhead on 9 February 1973. She sank in the Mediterranean in May 1978 after a serious fire.

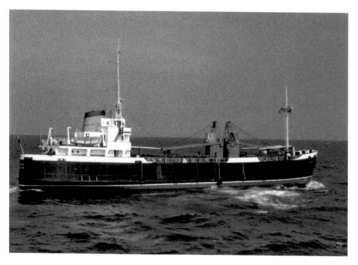

Peveril (3), 1964, 1,048grt, 62.48mx11.89m, 12kt, b. Ailsa Shipbuilding Co. Ltd. Engines by builder. Sold in 1981 and renamed *Nadalena H, Virginia Luck* in 1982, *Akak Princess* in 1983, *Zeina* in 1984, *Akak Star* in 1986, *Mariana 1* and *Mihmandar* in 1991 and was broken up in 2001.

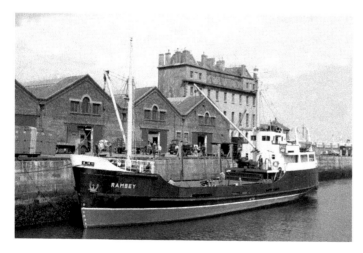

Ramsey, 1965, 446grt, 45.42mx8.53m, 10kt, b. Ailsa Shipbuilding Co. Ltd. Engines by builder. Purchased by R. Lapthorn & Co., Rochester, and renamed *Hoofort* in 1974. Sold to Cape Verde Islands interests in 1982 and renamed *Arquipelago*.

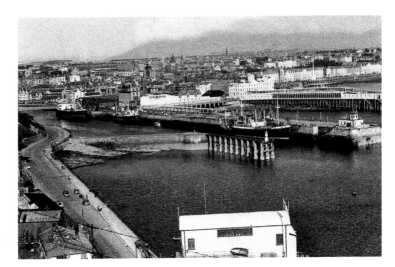

A rare sighting of (*l to r*) the cargo vessels *Peveril* (3), *Ramsey*, and *Fenella* (3) at Douglas.

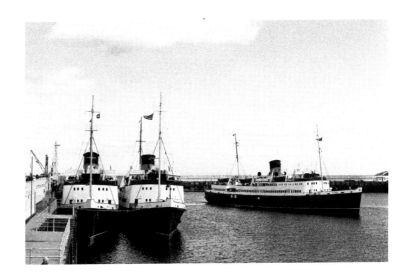

Tynwald (5), *King Orry* (4) and *Manxman* (2) in Douglas Harbour.

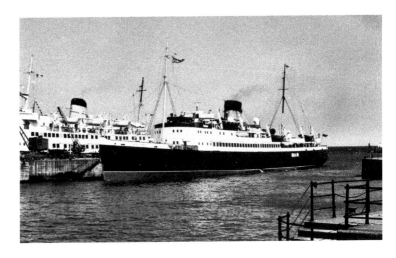

King Orry (4) and *Ben-my-Chree* (5) berthed at the King Edward Pier, Douglas.

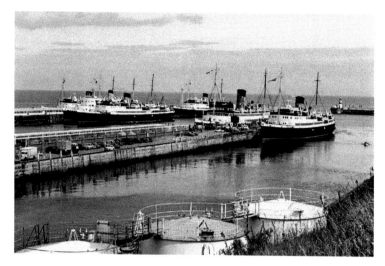

A quiet summer Sunday afternoon in Douglas harbour with (*l to r*) *Mona's Isle* (5). *Ben-my-Chree* (5), *King Orry* (4), *Manxman* (2), *Lady of Mann* (1) and *Snaefell* (5).

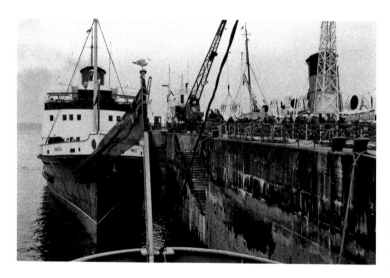

Snaefell (5) loads passengers and motor cycles at the King Edward Pier, Douglas.

Tynwald (5) moves slow ahead into the berth at the Victoria Pier at the end of a voyage from Liverpool.

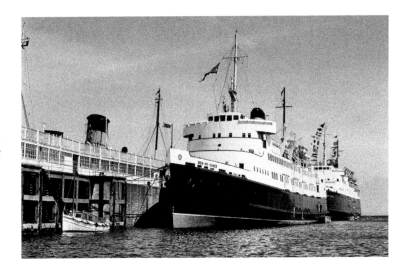

The Caledonian Steam Packet vessel *Caledonian Princess* (1961/3,629grt) is berthed astern of *Ben-my-Chree* (5) at Victoria Pier on a rare day excursion from Stranraer on 26 June 1968.

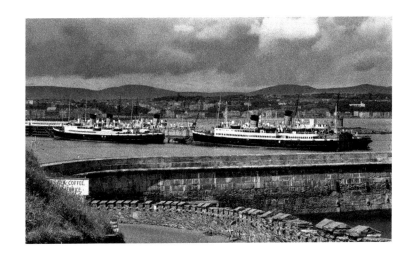

A view from the Douglas Head café in the 1960s.

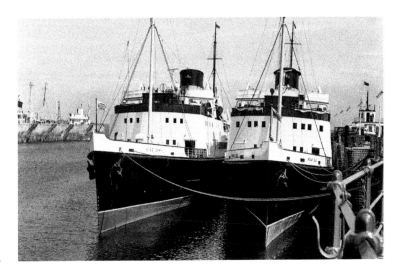

King Orry (4) and *Mona's Isle* (5) tied up at the King Edward Pier in 1967.

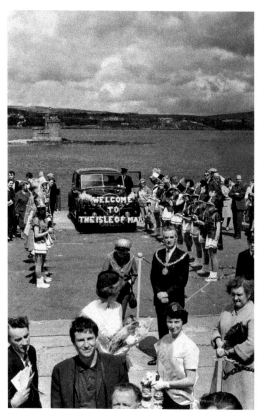

Manxman (2) was the first vessel to arrive at Douglas following the National Seaman's Strike in 1966. The strike took place between midnight on 15 May to midnight on 1 July 1966. *Ben-my-Chree* (5) and *Manx Maid* (2) were laid up at Barrow; *Mona's Isle* (5), *Tynwald* (5), *Snaefell* (5), *King Orry* (4) and *Manxman* (2) were laid up at Birkenhead; and *Lady of Mann* (1) was in Langton Graving Dock, at Liverpool. *Manxman* (2) was welcomed at the Victoria Pier on 2 July by the Mayor and Mayoress of Douglas, the Douglas Town Band, majorettes, streamers and hundreds of people lining the pier and sea front. *Manxman* arrived at 13.55, *Ben-my-Chree* (5) at 14.35 and *Mona's Isle* (5) at 15.00. All three steamers arrived at Douglas from Liverpool. *Lady of Mann* (1) sailed light from Liverpool to Ardrossan and took the 22.30 sailing to Douglas. *Manx Maid* (2) sailed from Barrow to Liverpool and departed at 15.30 to Douglas and on arrival she sailed to Ardrossan at 23.55 hours.

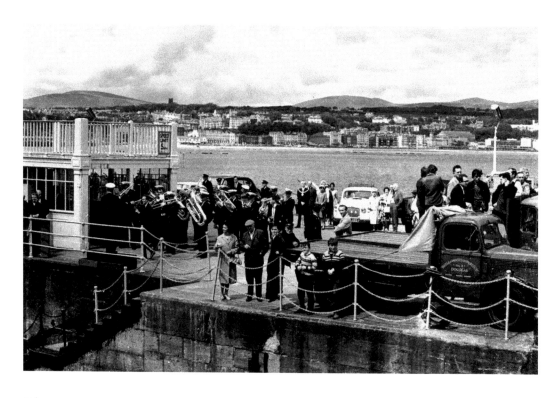

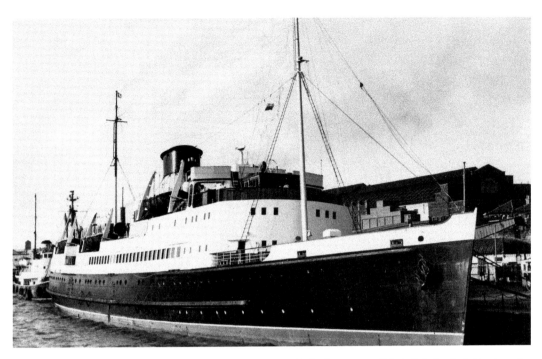

Mona's Queen, 1946, 2,485grt, 105.16mx14.38m, 21½ kt, b. Cammell Laird & Co. Ltd. Engines by builder. Her final voyage for the Steam Packet was on 16 September 1961 and she was renamed *Barrow Queen* when sold to Chandris Lines. She later became *Fiesta* and was employed on Mediterranean cruises until she was broken up at Perama in September 1981.

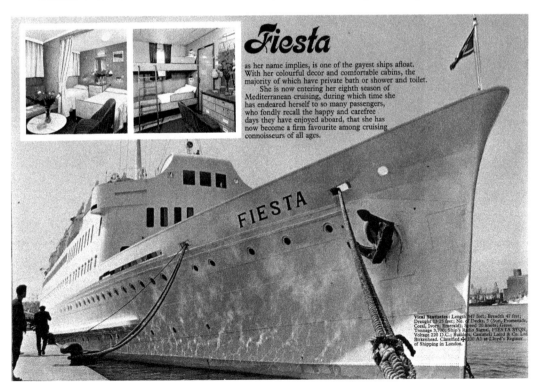

Fiesta

as her name implies, is one of the gayest ships afloat. With her colourful decor and comfortable cabins, the majority of which have private bath or shower and toilet.

She is now entering her eighth season of Mediterranean cruising, during which time she has endeared herself to so many passengers, who fondly recall the happy and carefree days they have enjoyed aboard, that she has now become a firm favourite among cruising connoisseurs of all ages.

Vital Statistics: Length 347 feet; Breadth 47 feet; Draught 13.25 feet; No. of Decks, 5 (Sun, Promenade, Coral, Ivory, Emerald); Speed 20 knots; Gross Tonnage 3,700; Ship's Radio Signal, FIESTA SYON. Voltage 220 D.C.; Builders, Cammell Laird & Co. Ltd. Birkenhead. Classified 100 A1 at Lloyd's Register of Shipping in London.

A brochure advertising a 'Mersey Beat Boat' cruise on *Lady of Mann* (1) (below) in the 1960s.

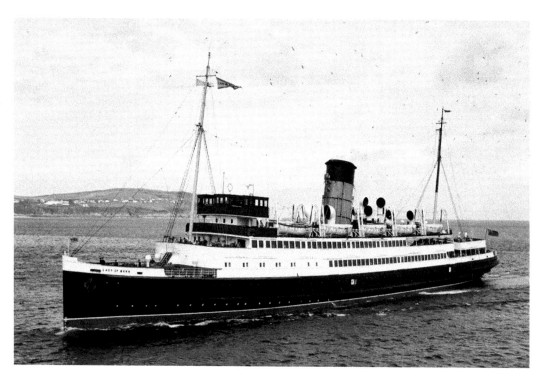

Right: 1971 brochure for Fleetwood to Douglas day excursions by the Steam Packet.

Below: *Duke of Lancaster, Manxman* (2), *Scottish Coast* and *Brookmount* at Belfast.

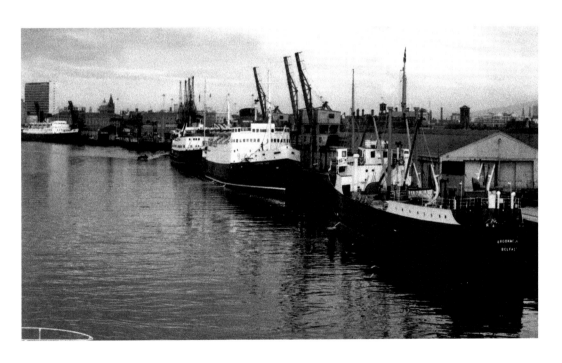

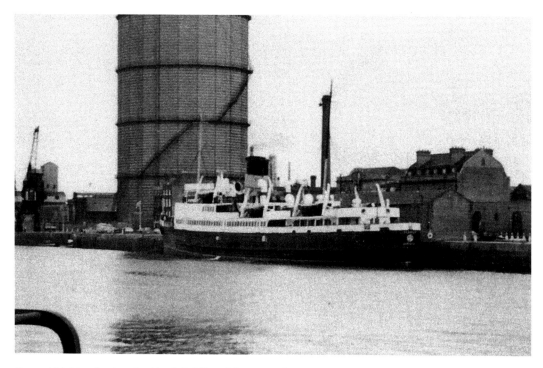

Tynwald (5) berthed at the North Wall, Dublin, on a day excursion from Douglas.

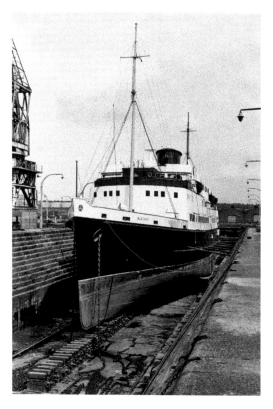

Manxman (2) during her annual overhaul in Bidston drydock at Birkenhead.

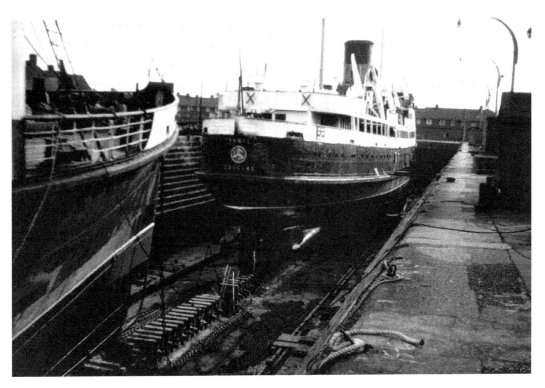

King Orry (4) and *Tynwald* (5) in drydock at Birkenhead.

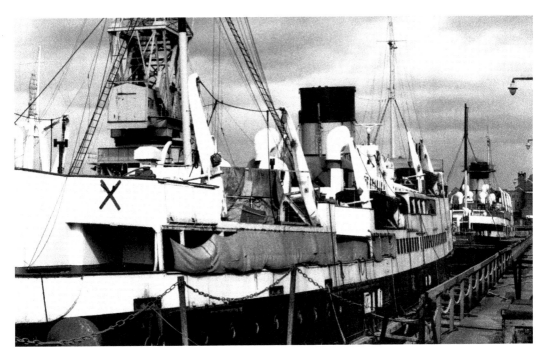

King Orry (4) and *Lady of Mann* (1) during an overhaul and hull painting in drydock at Liverpool.

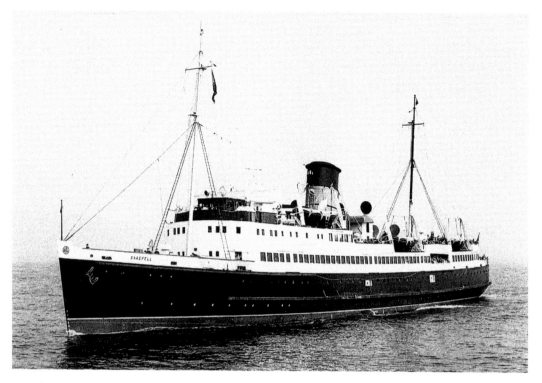

Snaefell (5) arriving at Douglas (above) and berthed in the East Float at Birkenhead in 1978 (below) prior to being towed to Blyth to be broken up.

Right: Another view of *Snaefell* (5) at Birkenhead in 1978.

Below: Vessels laid up for the winter in Morpeth Dock, Birkenhead in 1964.

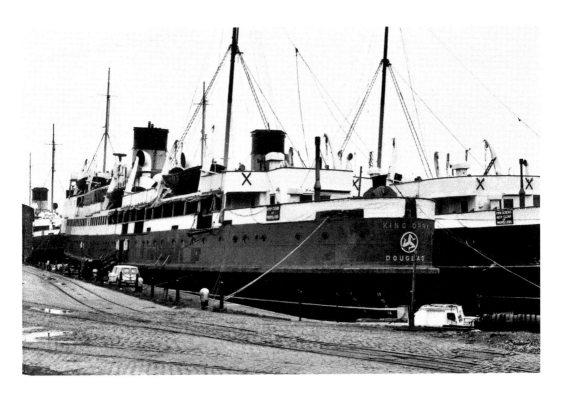

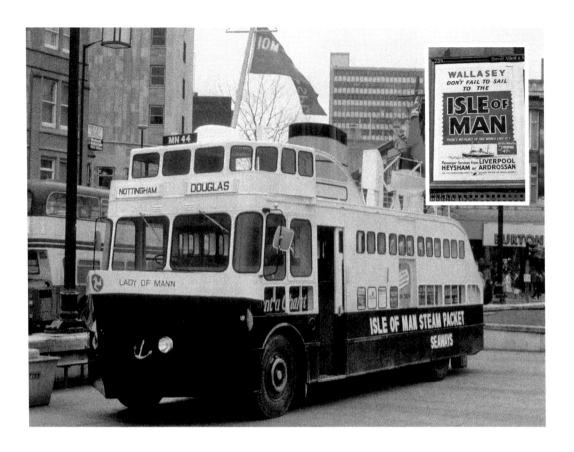

Above: The 'Lady of Mann' bus travelled around the north-west of England promoting holidays in the Isle of Man. *Inset:* Poster in Wallasey, Merseyside, advertising passenger services to the Isle of Man.

Left: Details of sailings from Liverpool to Douglas for the 1963 season.

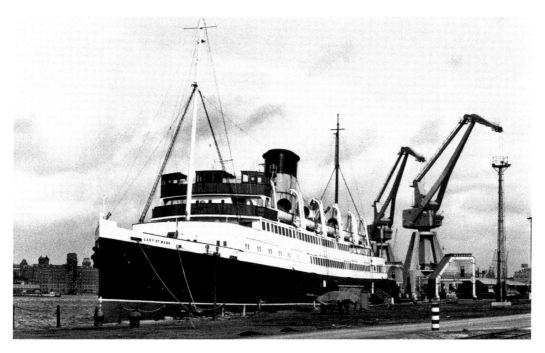

Lady of Mann (1) laid up at Cavendish Quay, Birkenhead, prior to a busy summer season in the 1960s.

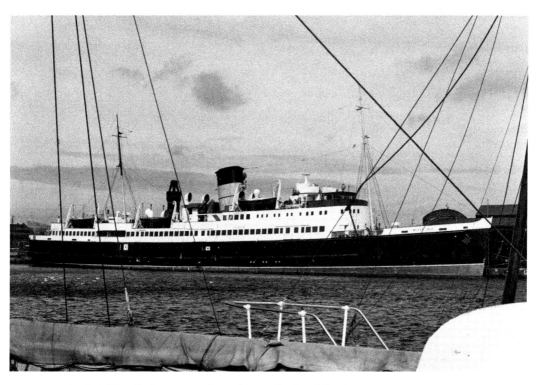

Mona's Isle (5) berthed in Morpeth Dock at Birkenhead for the winter.

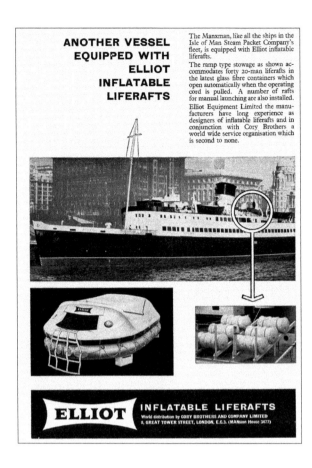

Elliot Inflatable Liferafts advertisement featuring *Manxman* (2).

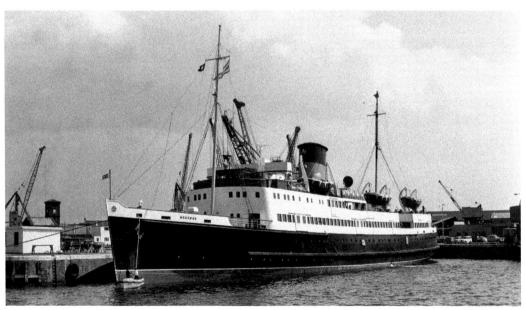

Manxman (2) berthed at Ardrossan.

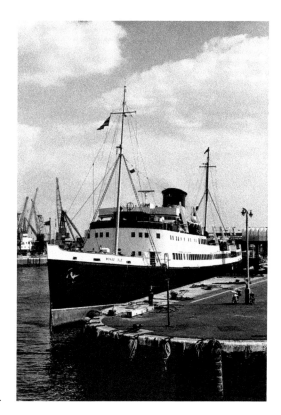

Mona's Isle (5) at Ardrossan.

Manxman (2) at Llandudno, North Wales.

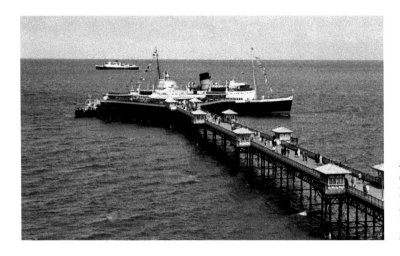

Mona's Isle (5) anchors in Llandudno Bay while *Snaefell* (5) and *St Trillo* load passengers at the Pier.

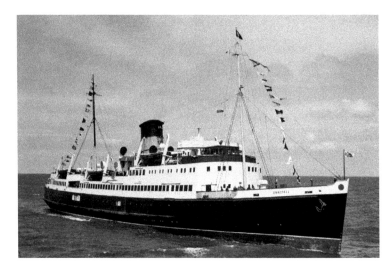

Snaefell (5) arrives back at Llandudno Pier to load passengers for the return trip to Liverpool after a successful afternoon cruise.

Manxman (2) prepares to berth at Llandudno Pier on a day excursion from Liverpool.

The fishing competition continues as *King Orry* (4) arrives from Liverpool.

The bridge lies empty after finished with engines is rung on the telegraph at Llandudno Pier.

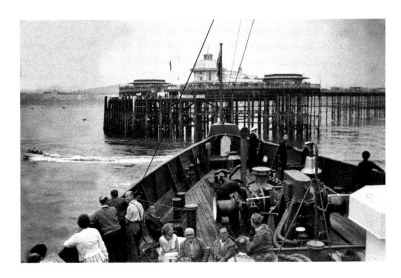

The end of another voyage from Liverpool Landing Stage to Llandudno Pier in 1965.

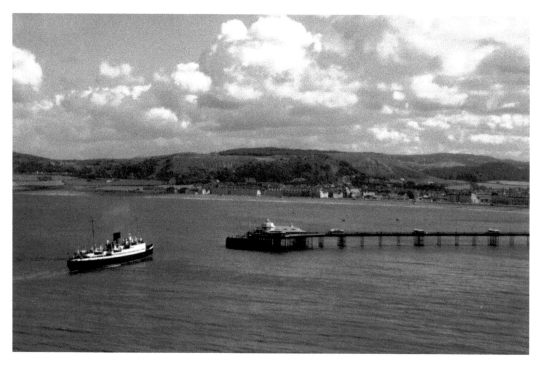

Tynwald (5) berths at Llandudno Pier.

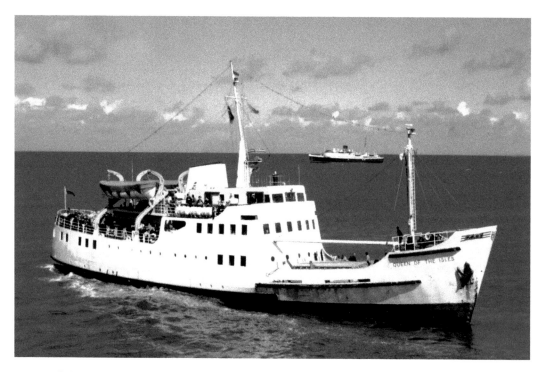

Queen of the Isles leaves Llandudno Pier on an afternoon cruise while *Tynwald* (5) anchors in the bay.

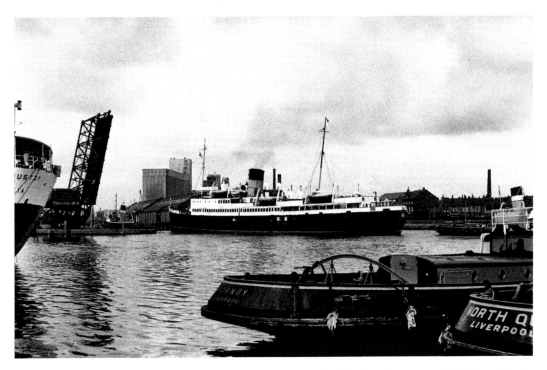

Tynwald (5) is assisted through the Four Bridges at Birkenhead on her way to be laid up for the winter in Morpeth Dock, Birkenhead.

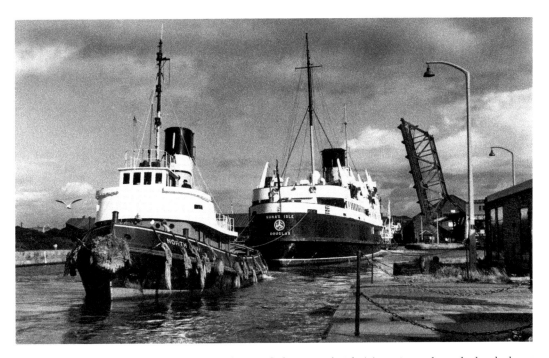

The Alexandra Towing Co. tug *North Quay* helps *Mona's Isle* (5) navigate through the docks at Birkenhead following a period in drydock.

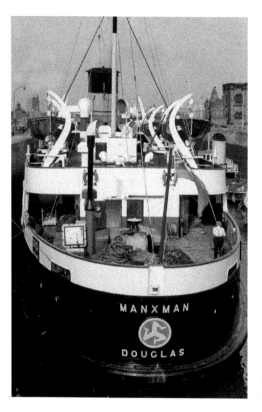

Manxman (2) (left) and *Manx Maid* (2) (below) in Alfred Lock at Birkenhead preparing to sail over to the landing stage at Liverpool.

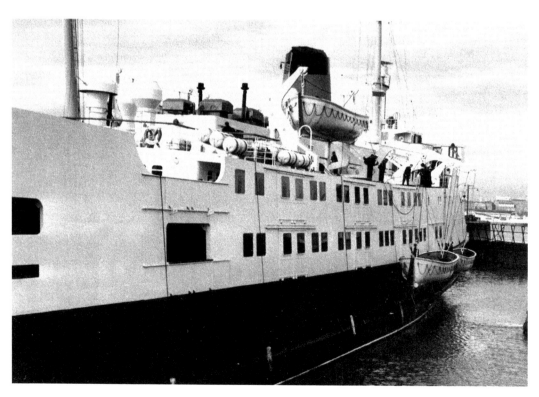

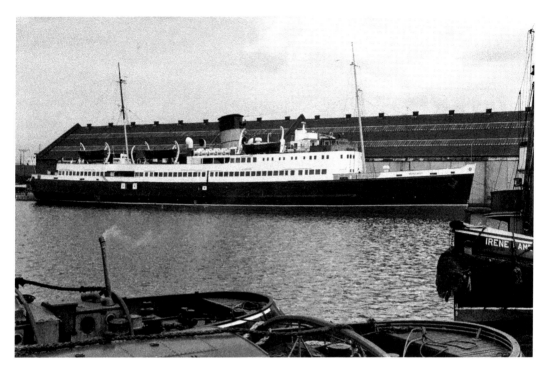

Manxman (2) berthed in the East Float at Birkenhead as she is prepared for the summer season.

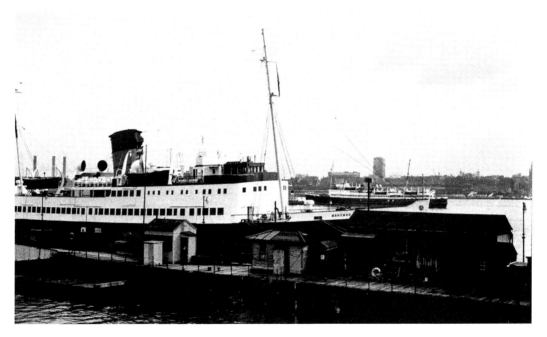

Tynwald (5) is towed into Alfred Lock at Birkenhead while *Manxman* (2) is berthed at the Wallasey Landing Stage. The stage was originally built for the cattle trade from Ireland, which were destined for the Lairage. It was demolished and the Twelve Quays Terminal is now on the site.

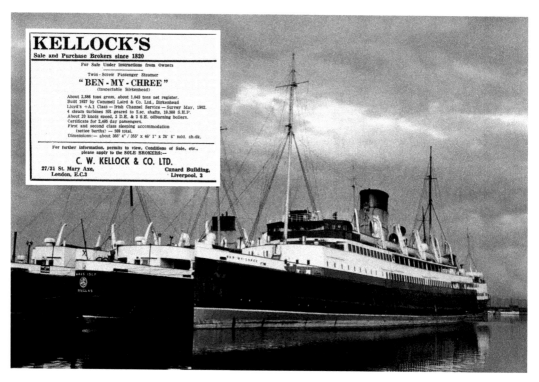

Ben-my-Chree (4) laid up for sale in Morpeth Dock, Birkenhead, in 1965.

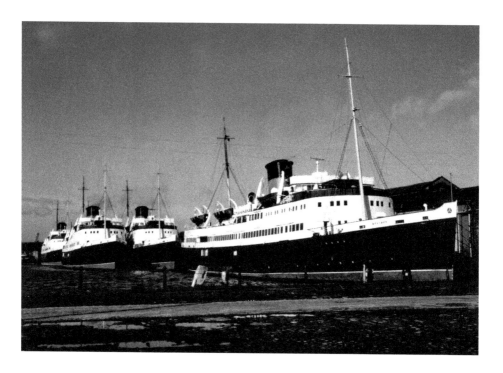

The five members of the *King Orry* class laid up together in Morpeth Dock.

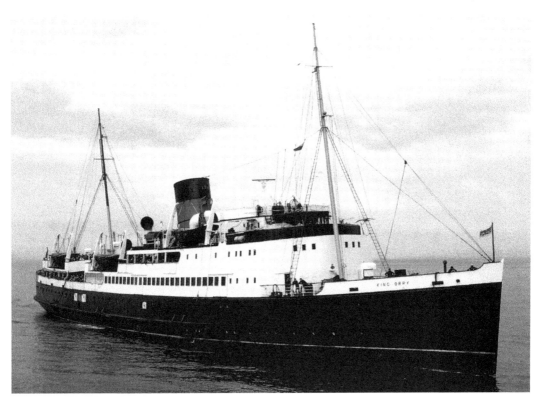

King Orry (4) at sea (top) and being assisted back into Morpeth Dock (below) by the Alexandra tug *Brocklebank* at Birkenhead following dry-docking at Bidston.

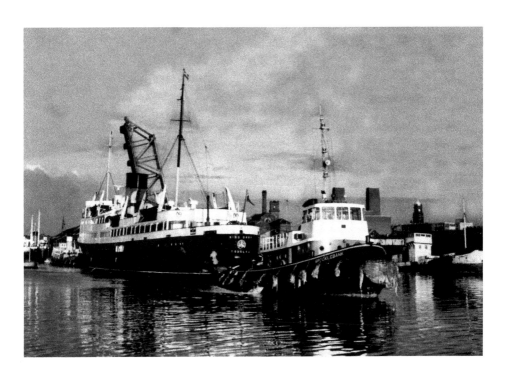

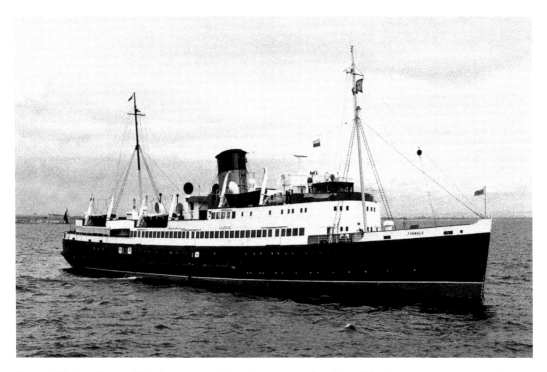

Tynwald (5) anchors off Ardrossan awaiting her turn to berth and load passengers, cars and motor cycles for Douglas.

The end of a summer day excursion to Llandudno on *Tynwald* (5).

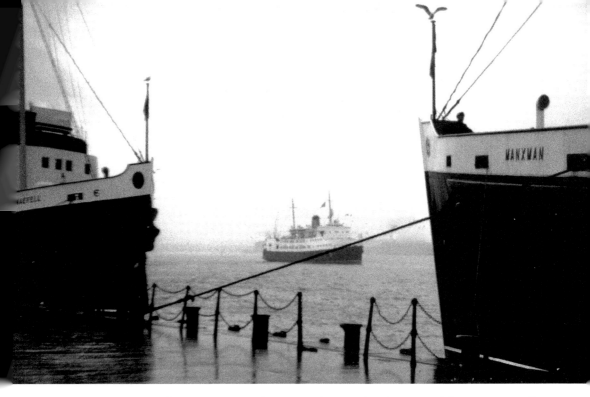

A wet summer Saturday at Princes Landing Stage, Liverpool, as *Manxman* (2) prepares to sail to Douglas.

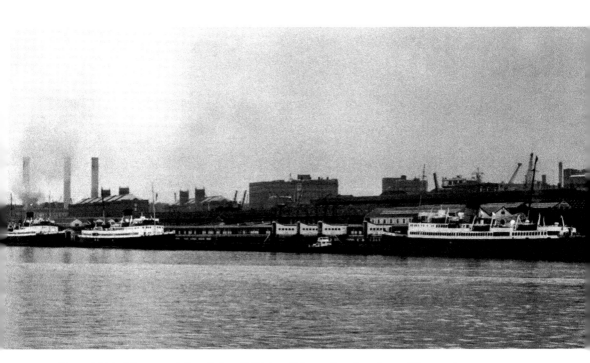

Tynwald (5), *Manxman* (2) and *Snaefell* (5) at Princes Landing Stage, Liverpool.

Promenade deck (above) on *Manx Maid* (2).

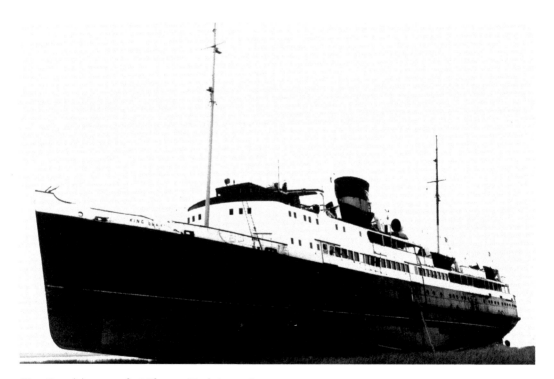

King Orry (4) aground at Glasson Dock in 1976.

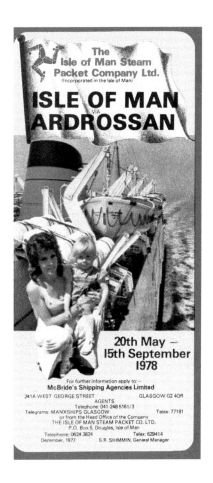

Isle of Man-Ardrossan leaflet for the summer season 1978.

WELCOME ABOARD — ISLE OF MAN STEAM PACKET Seaways

MAY	LIVERPOOL DEPART Sailing Time	DOUGLAS DEPART Sailing Time
Fridays, 13th, 20th	11.00	16.00
Thursday, 26th	10.30	16.00
Friday, 27th	10.30 or 15.30	16.00 or 2385
Friday, 27th	23.55	—
Saturday, 28th	10.30	16.00
Sunday, 29th	10.30	16.00
Monday, 30th	10.30	16.00
Tuesday, 31st	10.30	16.00
JUNE		
Wednesday, 1st	10.30	16.00
Thursday, 2nd	10.30	16.00
Thursday, 2nd	23.55	—
Friday, 3rd	10.30	16.00 or 23.55
Saturday, 4th	01.00 09.00 or 11.00	16.00 or 23.55
Saturday, 4th	23.55	
Sunday, 5th	10.30	16.00
Sunday, 5th	23.55	
Monday, 6th	10.30	16.00 or 18.00
Tuesday, 7th	10.30	18.00
Tuesday, 7th	23.55	
Wednesday, 8th	10.30	16.00 or 18.00
Thursday, 9th	10.30	16.00 or 23.55
Thursday, 9th	23.55	—
Friday, 10th	10.30	16.00, 18.00 19.30, 21.30 or 23.55
Friday, 10th	23.55	—
Saturday, 11th	10.00	18.00, 19.00 21.00 or 23.55
Saturday, 11th	23.55	
Sunday, 12th		16.00 or 23.55
Mondays to Thursdays, 13th to 30th	10.30	16.00
Fridays, 17th & 24th	10.30	16.00 or 23.55
Fridays, 17th & 24th	23.55	
Saturdays, 18th & 25th	10.30	16.00

JULY	LIVERPOOL DEPART Sailing Time	DOUGLAS DEPART Sailing Time
Fridays, 1st, 8th, 15th, 22nd, 29th	10.30	16.00 or 23.55
Fridays, 16th, 23rd, 30th	23.55	—
Saturdays, 2nd, 9th, 16th, 23rd, 30th	10.30	16.00
Saturdays, 9th, 16th, 23rd	23.55	—
Sunday, 31st	10.30	—
Sundays, 10th, 17th, 24th, 31st	—	16.00
Mondays to Thursdays, 4th to 28th	10.30	16.00
AUGUST		
Mondays to Thursdays, 1st to 31st	10.30	16.00
Fridays, 5th, 12th, 19th, 26th	10.30	16.00 or 23.55
Fridays	23.55	—
Saturdays, 6th, 13th, 20th, 27th	10.30	16.00
Sundays, 7th, 14th, 21st, 28th	10.30	16.00
SEPTEMBER		
Mondays to Thursdays 1st to 22nd	10.30	16.00
Fridays, 2nd & 9th	10.30	16.00 or 23.55
Fridays, 16th & 23rd	10.30	16.00 only
Fridays, 2nd & 9th	23.55	—
Saturdays, 3rd & 10th	—	16.00
Saturdays, 3rd, 10th, 17th, 24th	10.30	16.00
Sunday, 4th	10.30	16.00

DAY EXCURSION FARE — £11.00

CHILDREN under 5 years of age are FREE
5 years and under 16 years HALF ADULT FARE
Infants must be accompanied by an Adult

GROUP RATES – Every eleventh Adult in your group – FREE

DAY PASSENGERS ARE NOT PERMITTED TO CARRY LUGGAGE

The Company may withdraw or curtail any service or suspend or cancel any sailing as the Company may think necessary.

Isle of Man Steam Packet Seaways sailing details for 1973.

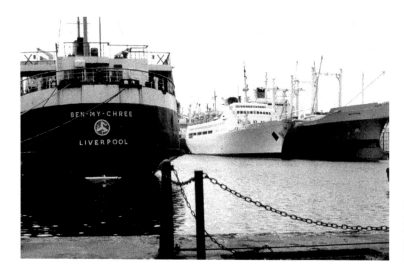

Ben-my-Chree (5) laid up in Vittoria Dock, showing her port of registry as Liverpool.

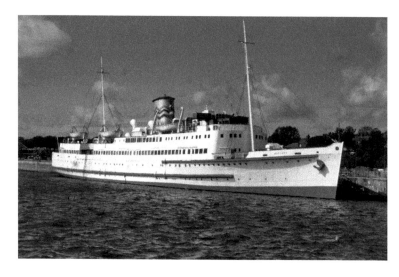

Manxman (2) berthed in Preston Docks.

Manx Maid (2) was broken up at Garston in 1986.

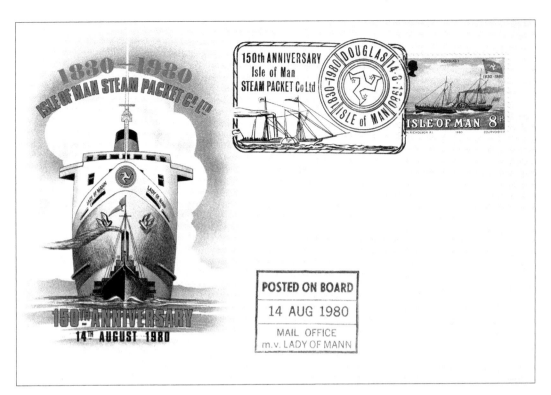

150th Anniversary first day cover and publicity material.

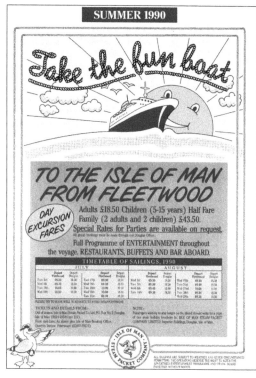

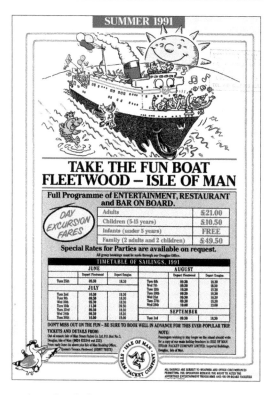

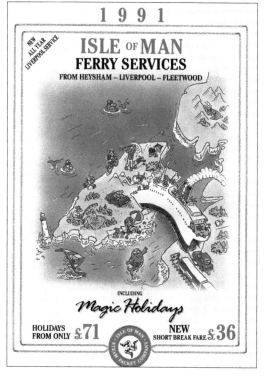

Sailing details for 1989, 1990 and 1991.

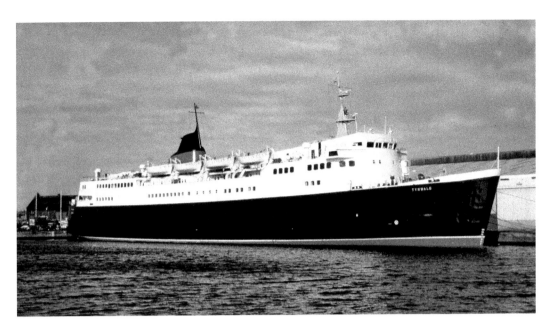

Tynwald (6), 1967, 3,762grt, 112.63mx17.40m, 19½ kt, b. Hawthorn Leslie Ltd, Hebburn.
Built as *Antrim Princess* for the Caledonian Steam Packet Ltd. Chartered to the IOMSPC from
5 October 1985. Her final voyage was on 19 February 1990 when she laid up and sold to Agostino
Lauro and renamed *Lauro Express*. She became *Giuseppe Dabundo* in 2003, *Stella* in 2006 and
was broken up in 2007.

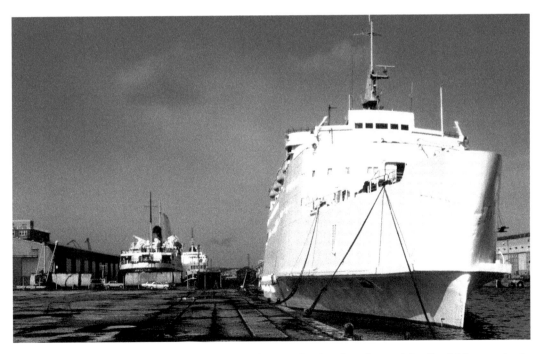

Al Fahad (ex-*Mona's Isle*) prepares to sail from Birkenhead Docks on 6 April 1986 for service in
the Red Sea.

Mona's Queen (5) in drydock at Birkenhead.

Lady of Mann (2) sails from Douglas for lay up at Birkenhead on 28 June 1994, when she was replaced by *Seacat Isle of Man*.

Mona's Isle (6) sails from Heysham to Douglas in 1985.

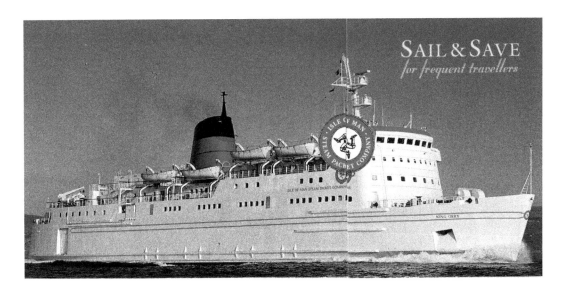

King Orry (5) in service.

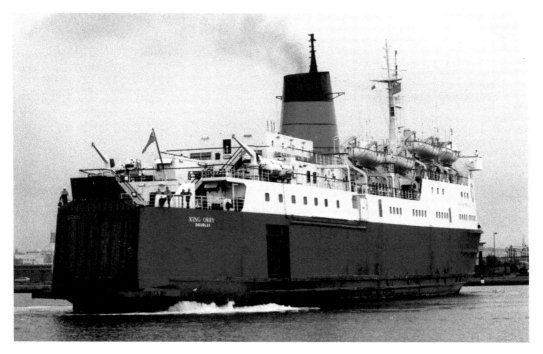

King Orry (5) moves astern to her lay up berth in Vittoria Dock, Birkenhead, following completion of her service for the Isle of Man Steam Packet in September 1998. She was sold, renamed *Moby Love* and sailed from Birkenhead on 23 October 1998.

Lady of Mann (2) during an annual overhaul in Canada Drydock, Liverpool.

 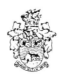

The Isle of Man Steam Packet Co. Ltd
(Incorporated in the Isle of Man)

Registered Office:
P.O. Box 5, Imperial Buildings
Douglas, Isle of Man

ADULT / ~~CHILD~~ / ~~INFANT~~
(delete as applicable)

№ 000072

**Liverpool/Llandudno
Day Trip
22 May 1997
MV Lady of Mann**

COUNTERFOIL
Not Valid For Travel
To be retained by passenger

Lady of Mann (2) took a special centenary 'Day Trip' sailing from Llandudno to Douglas on 22 May 1997. She sailed from Liverpool to Llandudno and took the anniversary sailing to and from Douglas, and then returned to Liverpool the same day with passengers on board.

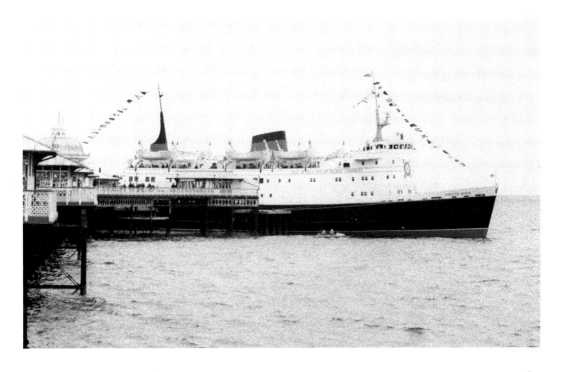

King Orry (5) on a winter Saturday sailing to Liverpool.

Ben-my-Chree (6) berths at the Twelve Quays Terminal at Birkenhead.

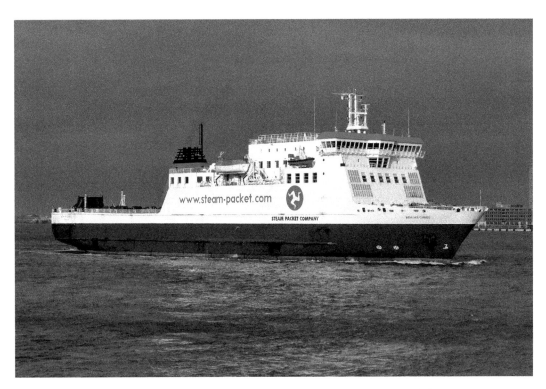

Ben-my-Chree (6) in the Mersey after her overhaul that increased her passenger accommodation.

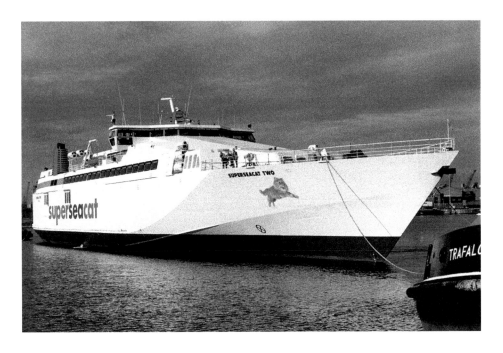

SuperSeaCat Two (1997/4,462t) in Liverpool Docks.

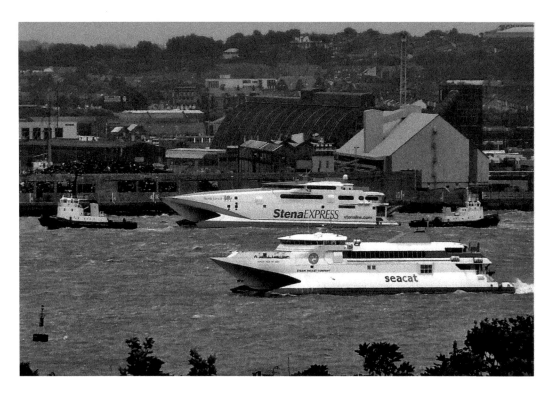

SeaCat Isle of Man (1991/3,003t) passes *Stena Lynx III*(1996/4,113t) off New Brighton in the River Mersey.

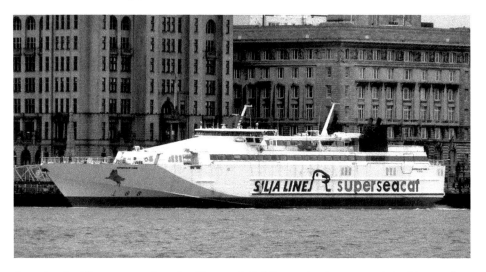

SuperSeaCat Three operated on the Liverpool–Dublin service in 1999 and the Liverpool–Douglas route the following year. In 2001, she was in service between Dover and Calais and Dover and Ostend. In the summer of 2002 she was again on the Liverpool to Dublin and Douglas services. In 2003, she was transferred to the Helsinki–Tallinn route for the Silja Line and she is seen here at the Landing Stage at Liverpool preparing to sail following an overhaul by Cammell Laird at Birkenhead.

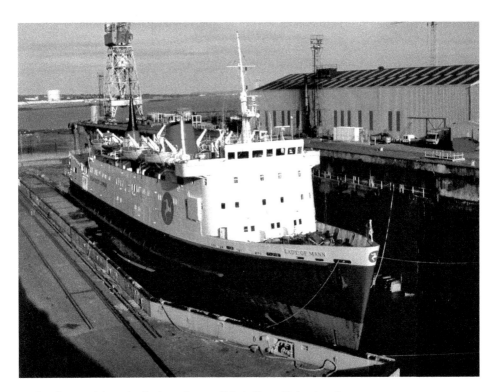

Lady of Mann (2) in drydock at Cammell Laird's at Birkenhead.

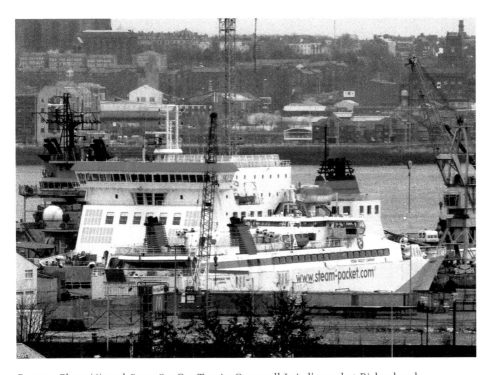

Ben-my-Chree (6) and *SuperSeaCat Two* in Cammell Laird's yard at Birkenhead.

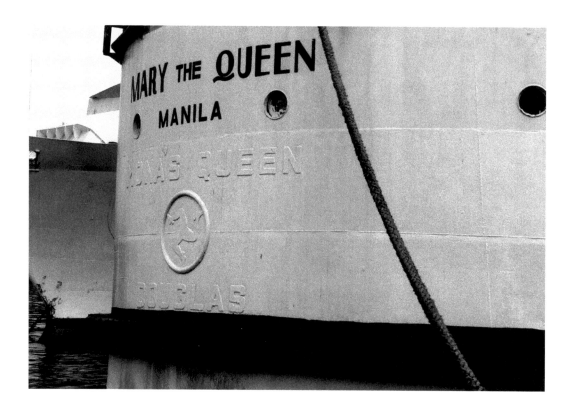

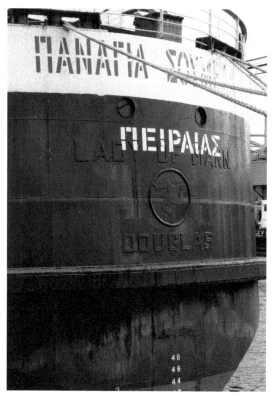

The names of *Mona's Queen* (above) and *Lady of Mann* (left) can be seen under their new names of *Mary the Queen* and *Panagia Soumela*.

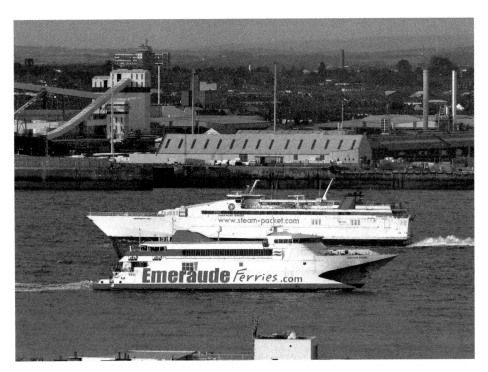

SuperSeaCat Two passes *Emeraude France* (1990/3,012t) in the River Mersey off Gladstone Dock.

The former Silja/Sea Containers floating terminal *Pontus* is towed out of the Mersey to Norway on 19 April 2006, after being used by the Steam Packet at the Landing Stage at Liverpool Pier Head since 2000.

Incat 050 (later *Manannan*) on her delivery voyage from Australia in the Suez Canal.

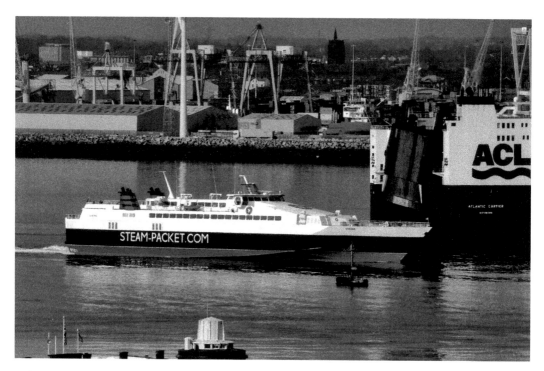

Viking (2) passes close to the stern of the ACL vessel *Atlantic Cartier* off New Brighton on the Mersey.

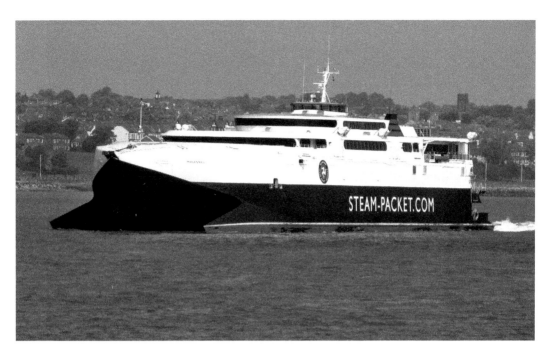

Manannan nears the end of a voyage on the Douglas–Liverpool service.

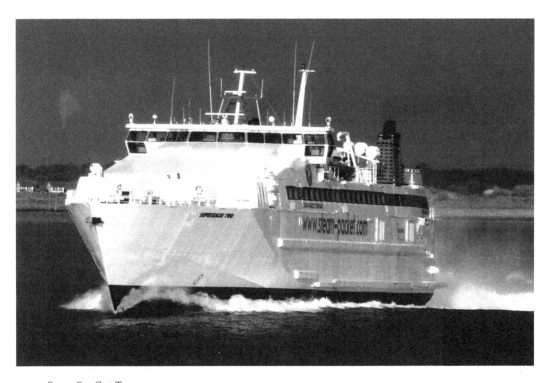

SuperSeaCat Two.

Ben-my-Chree (6) unloading vehicles and passengers at Douglas.

Ben-my-Chree (6) entering Canada Graving Dock at Liverpool for an overhaul.

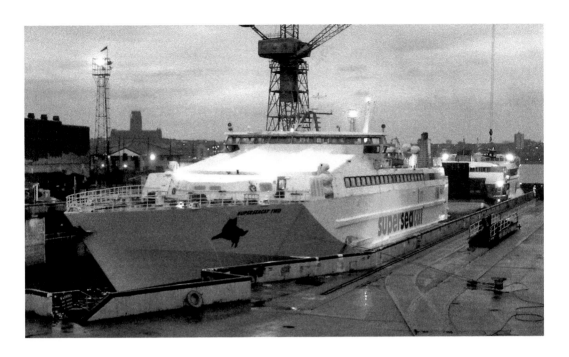

SuperSeaCat Two and *SeaCat Isle of Man* in drydock at Cammell Laird's yard at Birkenhead.

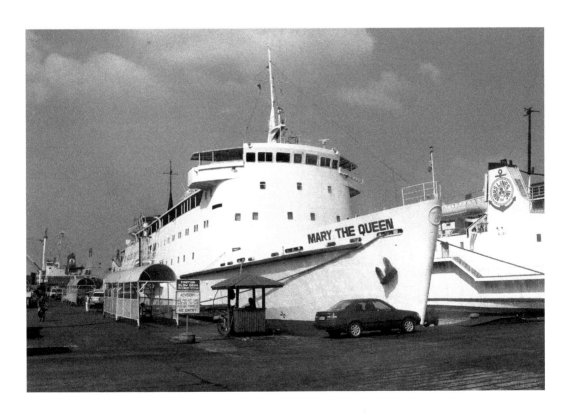

Mary the Queen (ex-*Mona's Queen*) at Manila, Philippines.

Manxman at Sunderland, prior to her being broken up in 2013.